WWW DESIGN

WEB PAGES FROM AROUND THE WORLD

BOOK
 Designer/Author: Daniel Donnelly
 Cover Design: Daniel Donnelly
 Design Associate: Christian Memmott
 Production Assistant: Shanti Parsons

CD-ROM
 Design: Interactivist Designs/Daniel Donnelly
 Programming: William Donnelly
 Production: William Donnelly, Jerry Garcia,
 Shanti Parsons, Christian Memmott

WEBSITE
http://www.inyourface.com

First published in the United States of America by:
Rockport Publishers, Inc.
146 Granite Street
Rockport, Massachusetts 01966-1299
Telephone: (508) 546-9590
Fax: (508) 546-7141

Distributed to the book trade and art trade in the United States by:
North Light Books, an imprint of
F & W Publications
1507 Dana Avenue
Cincinnati, Ohio 45207
Telephone: (800) 289-0963

Other Distribution by:
Rockport Publishers, Inc.
Rockport, Massachusetts 01966-1299

ISBN 1-56496-335-7

10 9 8 7 6 5 4 3 2 1

Printed in Hong Kong by Regent Publishing Services Limited

WWW DESIGN

WEB PAGES FROM AROUND THE WORLD

ROCKPORT
PUBLISHERS

ROCKPORT PUBLISHERS, ROCKPORT, MASSACHUSETTS

WWW

DESIGN

Web Pages from Around the World

Introduction
Revolution at 72 dpi

One site out of a hundred. It takes visiting that many sites to find one that is memorable. Producing this book required going through thousands of sites to find the seventy or so featured here that were more than just a beautiful home page.

The World Wide Web is an exciting medium for designers, with its promise of a potentially enormous global audience and freedom from the financial constraints of conventional color printing (although other technological cost constraints come into play), as well as its promise of a way to engage viewers in ways impossible via the printed page or the passive television screen. The Web draws designers and would-be artists like moths to a flame, but many fail. As in other creative media, many elements must work together to create a successful site. The individual elements can be so numerous that it is difficult to pinpoint exactly which quality makes a site appealing. The Web is such a strongly visual medium that text is often secondary to the graphics of a site. Visitors subconsciously assess a site by its graphics.

What I tried to do in this book is pinpoint as many of the discrete or obvious elements as I could and described how they pull the site together. Sometimes elements are easy to identify, as in the IUMA site (p. 134) where it is easy to point to the graphically pleasing button bar as a fine element, but even here, determining what makes the individual button bars so attractive is difficult—is it the bars themselves, the white space around them, or the way they are used in the overall design of the site? In the case of The Dominion, for the cable Sci-Fi Channel (p. 150), there are so many different elements that it is difficult to determine which element has the most appeal. When a site is broken down into individual pieces, it's hard to say whether an individual element can make or break a site on its own. Often a grouping of mediocre or unremarkable elements assumes an unexpectedly high creative stature. When visiting sites around the world, we encounter design sensibilities from different cultural backgrounds, and it can become even more difficult to discern specific elements or themes that are graphically complete and pleasing.

The Web revolution bears some interesting parallels to the desktop-publishing revolution in that it lowered the threshold for high-end production and publishing—72-dpi (dots-per-inch) design does not require color separation, large amounts of RAM, or mega-hard-drive space. As a means of personal expression, the Web is much more egalitarian than print, though there are serious cultural and economic issues pertaining to Web access. Someone living in Nairobi will probably have a more difficult time getting on the Web than a fourth-grade student growing up in Silicon Valley. When the Web is used as a means of corporate and commercial expression, big budgets will ensure a faster server, quicker download times, and better marketing, but there will be nothing qualitatively different in the appearance of the site, particularly in visual terms. In other words, an independent designer in Malaysia can afford to produce as nice a project as a London, Paris, or Manhattan firm could. Print or video quality, paper choice, and packaging all become irrelevant—the skill of the designer is what determines the difference. The limitations of the Web—small color palette and browser shortcomings in terms of handling plug-ins such as Java, Shockwave, or RealAudio, to name a few—apply to all Web publishers. Quality problems in the print or video world that might be solved by using more expensive equipment really are not solvable this way in Web design—technique is all-important.

The Web is in the process of defining itself as a medium, and until this process is much further along, the Web will continue to be discussed in terms of other media, mostly using publishing concepts like "page" and "sidebar." Someday, when online delivery of

video becomes viable, perhaps the terms "scene" or "close-up" will be used. The terms "link," "hotlink," and "hypertext" are unique to digital content, evoking non-linear experiences, as does the term "Web" itself. It is exciting to know that there are cadres of talented individuals, young and old, who are earning a living designing and shaping the Web of the future. Surely that Web will be significantly different from today's Web.

Today's Web designers derive their tools from print publishing applications such as Adobe PageMaker or QuarkXPress, which have components to add HTML (HyperText Markup Language) tags for Web publishing, or even to add multimedia sound and user inter-activity capability. Multimedia programs such as Macromedia Director have created applications that will strip files down to Web-playable size; Macromedia's version of this is the Shockwave/Afterburner combination. Even basic word-processing programs have export options to add HTML tags to plain vanilla documents. Photoshop offers the option to save an image as a GIF (Graphic Interchange Format). In essence, the same suite of tools that fueled the desktop revolution is also driving the 72-dpi revolution.

The Web is a dynamic design environment. While the basic Web design tools are those used in print publishing and multimedia, the underlying technology is in constant flux—always being improved, new features always being added. The basic HTML tag language is always being updated, as are browsers. Netscape Navigator and Microsoft Internet Explorer are the browsers of choice, and both now feature the availability of stable frame language to break up a single window page. New processes have been developed to transfer image-mapping programming from the server to the client to speed up download times considerably. Hardware requirements are being shifted to the viewer and to the server company. If the server is brought in-house, then the design firm can incur a considerable expense in hardware, software, and maintenance personnel, depending on the number of hits they expect to handle and how quickly the site loads. Many firms transfer this responsibility to service providers and pass the costs on to the client.

Rapid changes in Web tools, constant browser updates, new plug-ins (Java, Shockwave, RealAudio, Virtual Reality Modeling Language, etc.) present a challenge for designers and content developers. Whereas print and video professionals produce a static product—changeable only with the intent of creating a new, "revised" edition—Web professionals create shifting sand dunes where content and links form and flow to incorporate and embrace change. Sites become obsolete and tired easily, a tendency that a skilled design team can anticipate and work around. This book tries to highlight sites that bring freshness and innovation to the great wide Web.

What do the sites featured here have in common? They all pay attention to detail, not just on the home page, but on the subsequent pages as well. They feature innovative, well-executed designs characterized by effective use of color and shape as well as intelligently organized content. They make efficient and sensible use of available technology—whether it's Java scripting, GIF89a animation, Shockwave, or RealAudio—while at the same time keeping the total size of images, sounds, and animations small to ensure quick, reliable downloads without crashing.

Finally, the Web is a place of realization. Art need not be tangible, physical—it requires skill and a desire to communicate. It remains to be seen whether Web design will become accepted as a critical form in its own right.

Daniel Donnelly
Interactivist Designs

URL: http://www.qmm.com.au/hon

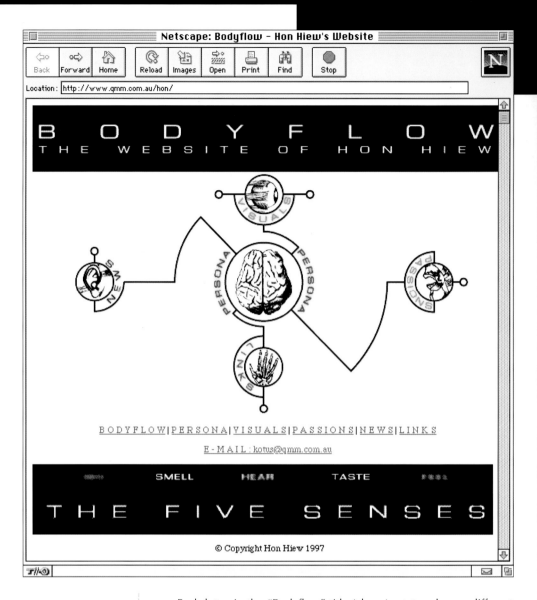

SELF-PROMOTIONAL

The Bodyflow Website by designer Hon Hiew is characterized by the theme of the five senses, which is used as an organizational metaphor. Each sense maps to an area of Hiew's portfolio—hearing to news, touching to links, sight to his on-line portfolio.

The opening page for each subsection features an anatomical illustration symbolic of each sense. Links to other pages are implemented by image-mapped typography and a navigation bar at the bottom of the page.

Color, simple circular shapes, and unique line treatments are additional elements that combine to unify the design.

Each letter in the "Bodyflow" title (above) rotates along a different axis, either from top to bottom or side-to-side, creating dynamic movement. In the black bar below the home page image each of the senses fades in and out, enlivening an otherwise static area.

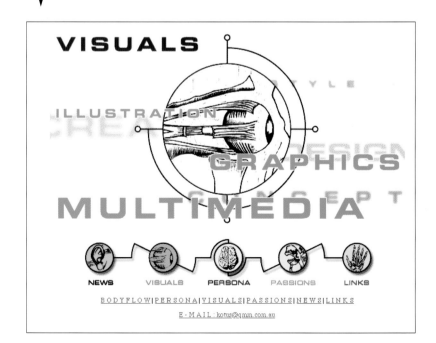

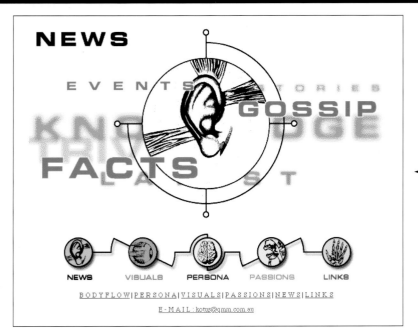

As in the home page navigation bar and title, the vertical navigation bar below features moving GIF89a animations. The hand and "Bodyflow" disks spin along a horizontal axis, much like flipping coins.

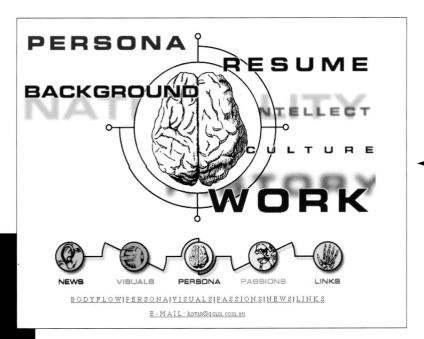

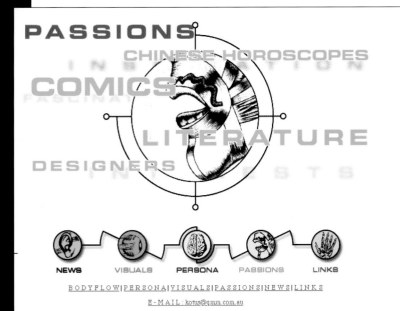

Project: Bodyflow Portfolio

Designer: Hon Hiew

Features: GIF89a animation

URL: http://www.newmedia.co.at/brody/e_books/default1

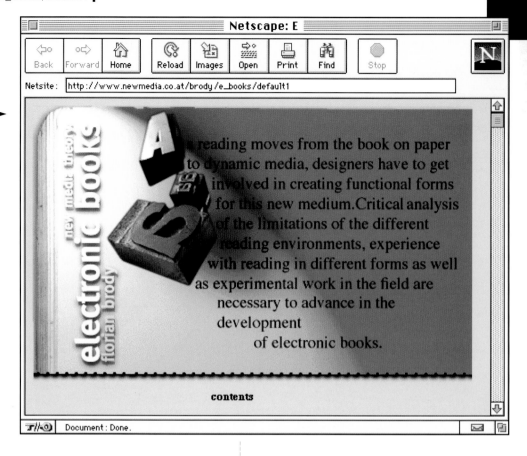

EDUCATIONAL

The BRODYnewmedia site was used as part of a graduate class on new media theory and electronic books taught by designer Florian Brody at the Art Center College of Design in Pasadena, California, though the site itself was compiled by BRODY newmedia art director Sarah Anastasia Hahn.

The site primarily displays student work in new media as developing art and communication forms in an attempt not to define new media but to explore their boundaries.

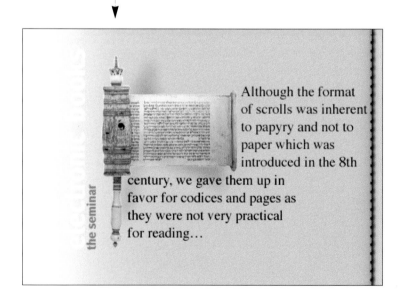

The home page image at the top uses elements that evoke the traditional book experience: a binding edge and stacked pages. Other pages on the site retain the binding edge and paper-like background as elements that give structure to the reading experience; the design also develops a convention of placing navigation links in the "margin" of the page.

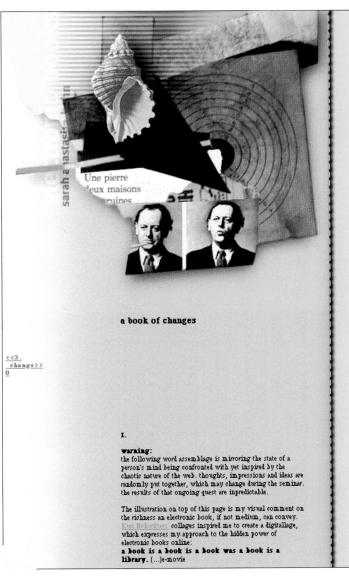

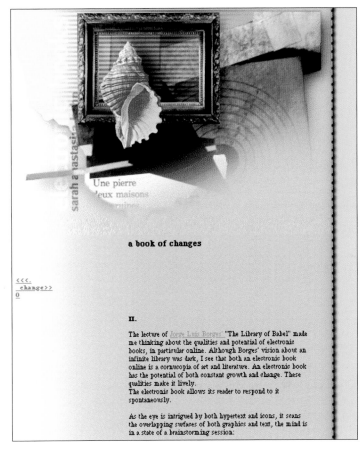

a book of changes

<<3.
change>>
0

I.

warning:
the following word assemblage is mirroring the state of a person's mind being confronted with yet inspired by the chaotic nature of the web. thoughts, impressions and ideas are randomly put together, which may change during the seminar. the results of that ongoing quest are inpredictable.

The illustration on top of this page is my visual comment on the richness an electronic book, if not medium, can convey. Kurt Schwitters' collages inspired me to create a digitallage, which expresses my approach to the hidden power of electronic books online:
a book is a book is a book was a book is a library. [...]e-movie

a book of changes

<<<.
change>>
0

II.

The lecture of Jorge Luis Borges' "The Library of Babel" made me thinking about the qualities and potential of electronic books, in particular online. Although Borges' vision about an infinite library was dark, I see that both an electronic book online is a cornucopia of art and literature. An electronic book has the potential of both constant growth and change. These qualities make it lively.
The electronic book allows its reader to respond to it spontaneously.

As the eye is intrigued by both hypertext and icons, it scans the overlapping surfaces of both graphics and text, the mind is in a state of a brainstorming session:

The student work above, left and right, is a self-reflective presentation of the experience of examining the concepts of new media. The graphical images are the artist's attempts to portray the chaotic nature of the Web. The student work below, left and right, are collage splash pages for the essay section of the site.

Project: Electronic Books

Design firm: BRODYnewmedia

Designers: Florian Brody,
Sarah Anastasia Hahn

Student Designers:

Matthew Grenby,

Fred Manskow Nymoen,

Tyrin Eduardo Pereida,

Daniel Schubert,

Muneharu Yoshida,

Matthew Lamson Simons,

Thomas Mueller (TA)

11

URL: http://www.ping.be

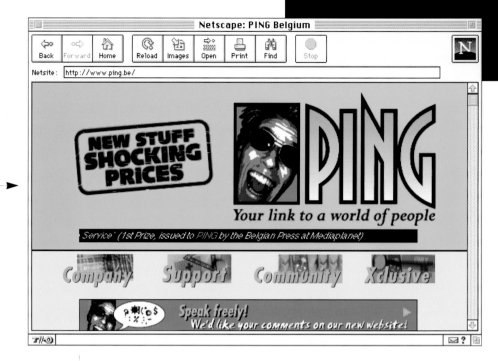

COMMERCIAL

PING is a Belgium-based Internet service provider (ISP) that has taken the time to produce a high-quality, creatively designed Website to promote the company's services.

Bright colors and a limited palette make for a quick download for visitors to the site's home page. Once there, potential users can easily find their way around the site. This site features clearly labeled buttons and presents information in an organized manner.

Frames are used within various areas of the site, as are GIF89a animations.

This long company page could have been designed as a short, boring block of HTML text with hyperlinks, but the designers instead chose to break up the copy as an appealing list, itself divided by rotating GIF89a animations that loop until the viewer clicks away to another page.

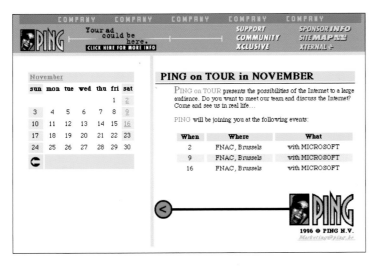

The first three Web pages shown at left incorporate frames.

The calendar frames make it simple for the viewer to check important and specific dates without having to wait for the images to reload.

The second and third pages show how frames can manage multiple levels of content. Clicking on a green circular button presents the viewer with several other links to choose from (bright pink circles). Clicking on one of the pink circles then presents the main content in the larger third frame at right.

Project: PING Belgium

Design firm: In-house

Designers: Dirk Zurngenter,

Peter Van Hees,

Bernard Gillbrecht

Illustrator: Bart De Neve

Programmers: Mark Van Hamme,

Peter Van Hees,

Marchteet Garrels

Photographer: Peter Van Hees

Features: GIF89a animation

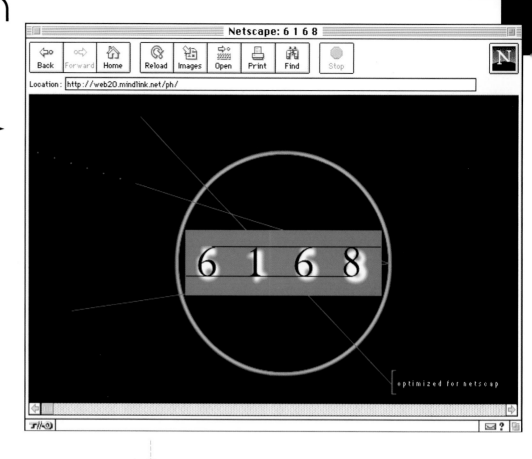

ART EXHIBIT

6168, an online art exhibit, got its unique title from the birth dates of the site's two Canadian creators, photographer Peter Horvath and multimedia designer Sharon Matarazzo.

They have created a minimalist look at modern culture, complete with a dial-up look at *TV Guide* history. During the process of the exhibit's creation, viewers were able to contribute their own writings and designs to the site.

The designers' grasp of color theory and contemporary design can be seen throughout the site.

Single hypertext links that guide the viewer through the various stories and essays keep navigation simple.

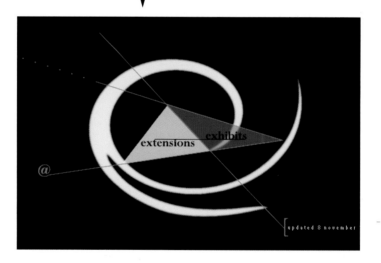

The 6168 splash page offers users a single point of entry (above). Clicking on the logo leads viewers to the main contents page (middle). Here viewers can choose the main "Exhibits" area of the site, where they can view stories composed of hyperlinks and animated GIFs (right), or click on "Extensions" and check out the creators' list of art-related links.

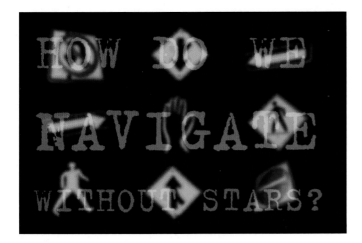

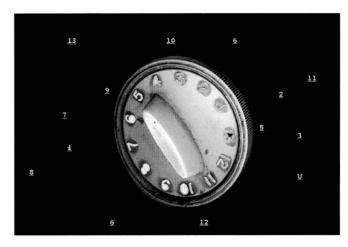

Interactive pages such as the ones above (starting clockwise from top left) force viewers to interact with the design. To stimulate viewer interest, after the word "How" pops in, the viewer must click on each successive word to finish the question. Unique designs such as the TV dial above offer an interesting layout of hypertext links. Viewing the HTML code, <tt>1231231213, reveals that the designers used multiple numbers colored black to move each of the numbered links into a specific position. The HREF added to the number "13" highlights the link, making it look as if it were floating by itself.

Peter Horvath was born in 1961 in Toronto, Canada. During his youth, he devoted his time to photography. In 1981, he established a studio in downtown Toronto, and spent the following years working as a photographer, developing his technical and aesthetic skills.

In 1985, and 1987 he briefly lived in Milan and Paris, respectively. When he returned to Toronto, his approach to photography had been significantly altered and shifted direction. Horvath entered a prolific period of experimentation, motivated by newly realized artistic intentions, and created a

Project: 6168

Design firm: Mco Digital Productions

Designers: Peter Horvath, Sharon Matarazzo

Features: GIF89a animation

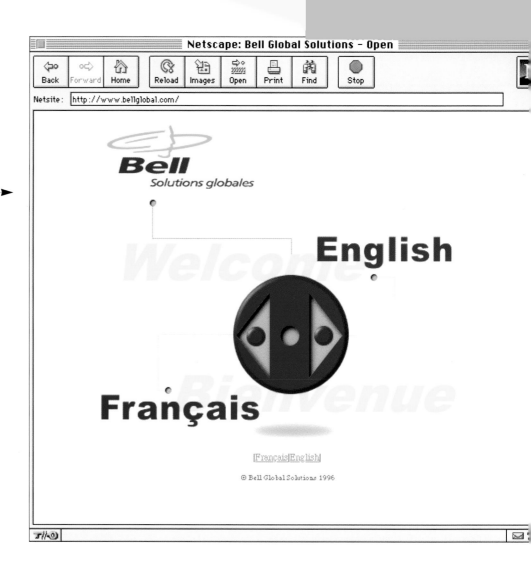

Netscape: Bell Global Solutions – Open

Back | Forward | Home | Reload | Images | Open | Print | Find | Stop

Netsite: http://www.bellglobal.com/

Bell
Solutions globales

Welcome

English

Français

Bienvenue

|Français|English|

© Bell Global Solutions 1996

COMMERCIAL

Bell Global Solutions offers visitors to their site a splash page that allows them to choose either French or English before heading onto the home page.

The Website presents visitors with the opportunity to communicate and conduct business more efficiently using Bell Global Solutions's services. In developing this site the designers have also produced a creative interface for navigation.

Using image-mapped graphics and button bars, the designers have created a contemporary site with subtle overtones of old-fashioned telecommunications (such as the stylized rotary dial on the home page).

Choosing a simple palette of blues and oranges helps to optimize the site for quick download and allows room for incorporating an animated GIF89a at the top of the home page. Using the icon image from the splash page, the designers have created a slider animation where the icon slides across the bar at the top, uncovering the "Global Links" link underneath.

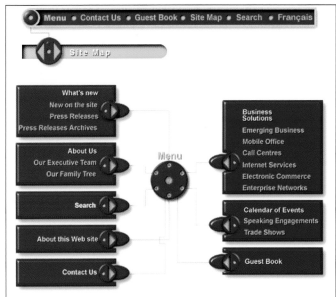

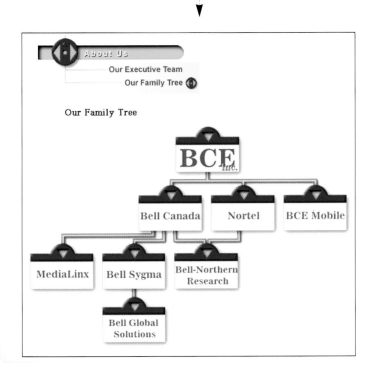

The designers have given each page its own unique look, while keeping the continuity of the site by continuing the color scheme throughout each page. Drop shadows and highlights on the rounded, beveled edges of the graphics (such as the navigation bars on the site map, above) give the pages depth.

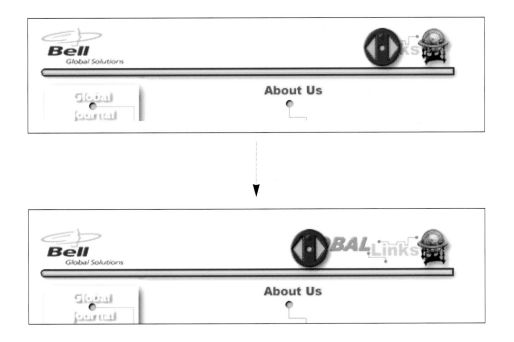

Project: Bell Global Solutions Public Website

Client: Bell Global Solutions

Design firm: Inform Interactive Inc.

Designer: Shy Alter

Programmers: Bryan Zarnett, Jason Moore, Paula Vaugeois

Features: Java scripting, PERL scripting

URL: http://www.fivaonline.com

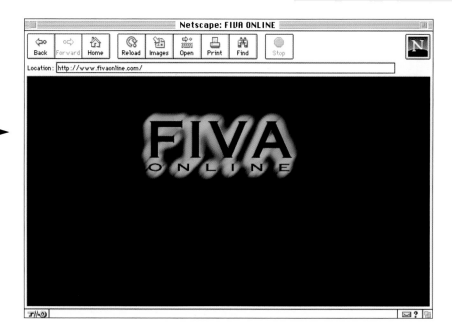

FIVA (Festival of Interactive and Virtual Arts) Online began as a Web-based media arts festival—a timely online event of interactive and virtual arts.

The latest FIVA event invites new media artists to create, mold, and extend a dynamic, interactive gallery in order to promote the latest artistic use of new media technologies.

The FIVA Online site features a black background that accentuates glowing, neon-like graphics and computer-generated art.

The splash page for the FIVA Online site sets the tone for the rest of the pages. A bright orange glow around the logo contrasts powerfully with the black background.

A GIF89a animation mimics electricity crackling across the logo (below).

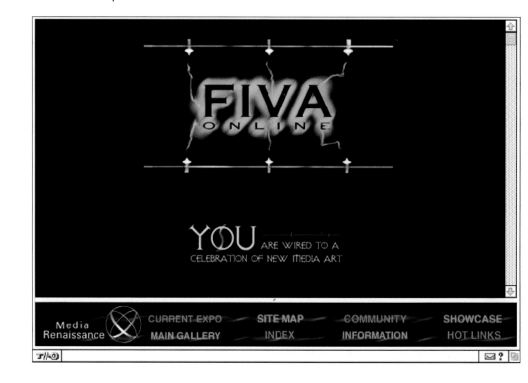

Beautiful imagery and illustrations are showcased on every page of the site. For easy navigation the designers used frames, keeping the navigation bar consistently running across the bottom for easy access and quick navigation.

Project: FIVA Online

Design firm: Media Renaissance Inc.

Designers: Jean Ranger, Phillip Greene, Megan Durnford, Yan Martineau

Illustrator: Jean Ranger

Programmers: Megan Durnford, Duncan Swain

Features: GIF89a animation

URL: http://www.danadata.dk/planet

Location: http://www.danadata.dk/planet/

The intro page to The Planet opens with a lighthearted illustration that sets the mood of the design firm's site, complemented by rounded typography and bright color schemes.

SELF-PROMOTION

The Planet is a freelance design studio founded by four Danish designers. Their mission, as they see it, is to "beat some style into multimedia and the Web."

The elements the designers use to "beat" some style into their Website are a colorful, folder-like design with layered tabs, and a full-screen page design, best viewed on a large monitor. To accommodate users with smaller monitors, The Planet keeps the main navigation and content areas to the far left of the screen.

The Planet uses contemporary typography, bright colors, and fun illustrations to make browsing enjoyable. The designers demonstrate their design skills and grasp of technology by incorporating Shockwave animations, sound loops, and GIF89a animations.

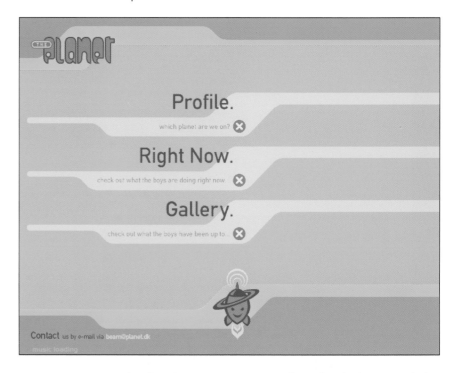

The Planet's contents page is simple, with only three main links, making access to the information quick and easy. Entering the page sets a Shockwave music loop into play, continuing until the user clicks on a link to another page.

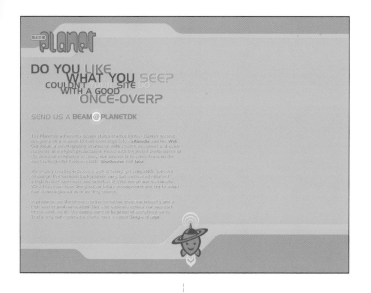

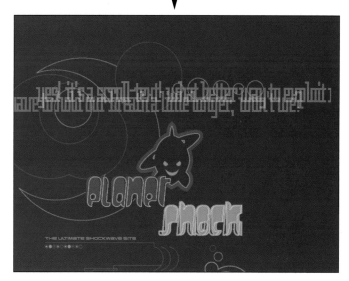

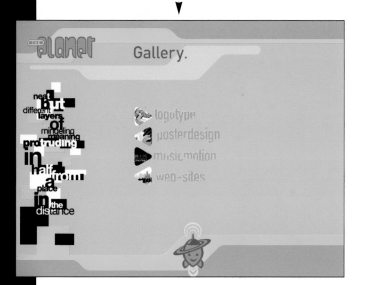

An animated GIF "@" symbol pulsates continuously (top left), and two Shockwave animations, the circling planets (middle left) and a scrolling text bar (middle right) add movement to stagnant pages. These creative elements demonstrate the firm's grasp of Web tools and technology.

Black-and-white layered type on the firm's "Gallery" page contrasts nicely with the color scheme used throughout the site. This limited color palette keeps download time for each page to a minimum.

Project: The Planet

Design firm: The Planet

Designers: Rasmus Keldorff, Mads Rydahl, Jacob Tekiela, Søren Ebbesen

Illustrators: Mads Rydahl, Rasmus Keldorff

Programmers: Rasmus Keldorff, Xavier Pianet

Photographer: Morten Møller

Features: Shockwave animation, GIF89a animation

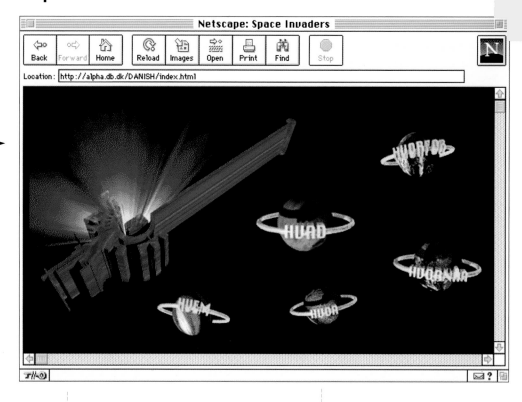

EDUCATIONAL

The Space Invaders site is the online presence for an innovative multimedia education program in Denmark. Although the school's name does not sound serious, it is, in fact, quite appropriate.

The school recognizes that the education and tools required by computer-based multimedia designers have not been established—thus, its philosophy is that multimedia design education should be in a creative, liberating environment combining people of different backgrounds, experience, and qualifications in order to create a whole new profession. The Website embodies this creative and liberating environment.

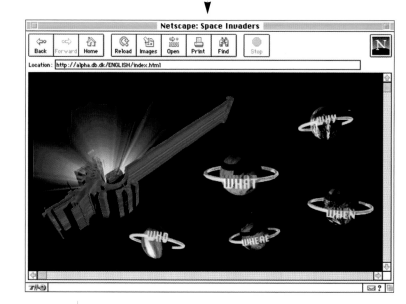

The bilingual site imparts a feeling of freedom, whimsy, and simplicity, with simple planetary icons representing the who, what, where, when, and why of the Space Invaders school.

Each sub-page is divided into three frames, with the top frame indicating the area (who, what, where, and so on), the side frame displaying icons for the main areas, and the middle frame displaying the actual content. This allows the main navigation icons to load into memory rather than having to reload each time the viewer follows a new link.

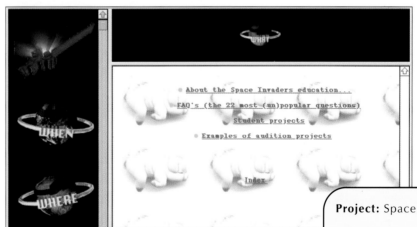

Project: Space Invaders

Design firm: Space Invaders

Designers: Norm Macleod, Xavier, John Paulin Hansen

Illustrators: Norm Macleod, Joern Thinggaard Laursen

Programmer: Norm Macleod

Photographers: Norm Macleod, Joern Thinggaard Laursen

URL: http://www.evitech.fi/cgi-bin/random_add.pl

Netscape: aRTIFEX hOMEPAGE

Back Forward Home Reload Images Open Print Find Stop

Netsite: http://www.evitech.fi/cgi-bin/random_add.pl

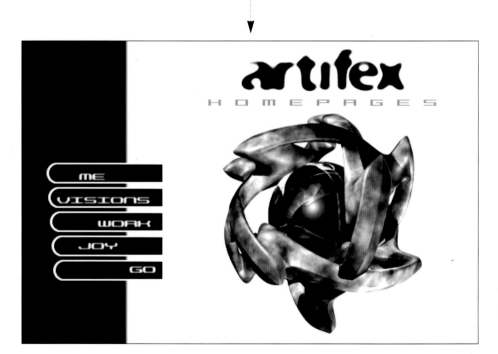

SELF-PROMOTION

Artifex is a self-promotional Website created by Henri Loikkanen, a design student living in Espoo, Finland.

The home page to Artifex greets visitors with a stark white background contrasted with a bold black divider bar and five main buttons used to navigate the site.

Two 3-D images load randomly on the home page, one with a bluish cast that sets the tone for the various illustrations and imagery found on subsequent pages, and one a completely black-and-white icon.

For those who want to view the Website in color, the designer created a link at the top left of his home page that leads to a site where all of his work can be viewed in color.

The 3-D duotone image used on the home page and other tinted images used throughout the site contrast nicely with the stark black and white of the pages, adding to the contemporary look of the overall design.

The designer used two distinct styles to create a low-bandwidth, black-and-white version of his portfolio (top and bottom) and a higher bandwidth color version where viewers can check out his 3-D imaging and illustration skills (middle).

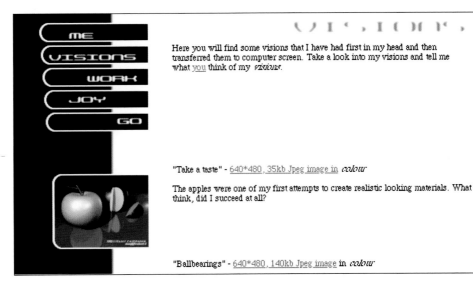

VISIONS

Here you will find some visions that I have had first in my head and then transferred them to computer screen. Take a look into my visions and tell me what you think of my *visions*.

"Take a taste" - 640*480, 35kb Jpeg image in *color*

The apples were one of my first attempts to create realistic looking materials. What think, did I succeed at all?

"Ballbearings" - 640*480, 140kb Jpeg image in *color*

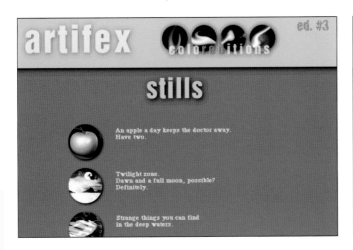

artifex colorettions ed. #3

stills

An apple a day keeps the doctor away. Have two.

Twilight zone. Dawn and a full moon, possible? Definitely.

Strange things you can find in the deep waters.

artifex colorettions ed. #3

dawn

A little animation created for the Assembly '95. Creation time: two weeks (needless to say the two weeks just before the party) Software used: TDI Explore 3.01 Hardware used: SGI Iris Indigo Entry 4000

mpeg 13 Mb with sound SGI movie 9 Mb no sound

"Science Fiction" - 800*600, 67kb Jpeg image in *color*

During one boring night it happened, something had to be done. This is what I came Inspired by the spaceships of the 60s.

d a w n

My contribution for the Assembly'95 Animation competition held in Helsinki. Abou weeks before the competition I decided to make an animation afterall. This is what I with. About 1000 frames of spaceships flying in a city catching its first rays of sunli Sounds better than it looks really. I had lots of ideas that I would have liked to inclu animation but the competition was closing too soon. The mpeg animation includes in Almost in THX.

Project: Artifex Portfolio

Designer: Henri Loikkanen

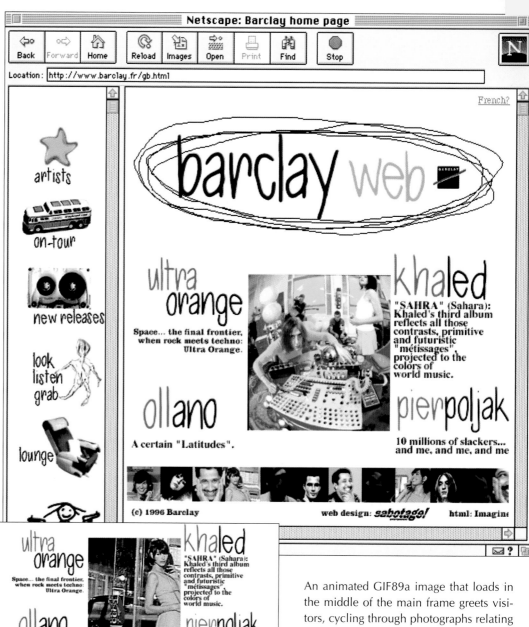

Location: http://www.barclay.fr/gb.html

COMMERCIAL

Barclay Web, the music 'zine designed by Sabotage! Entertainment, serves as a great resource for anyone interested in finding out about alternative European bands and artists. The site features a large listing of artists, tour dates, and downloadable music clips from various artists, as well as a "Lounge" area where viewers can exchange information on their favorite artists.

All the Website's features are available in French and English. Viewers can access either language by clicking on the hyperlink at the top of the main frame. Because the link is in this position, viewers don't have to wait for the full page to load before choosing which language to visit in.

An animated GIF89a image that loads in the middle of the main frame greets visitors, cycling through photographs relating to the four current features listed on both sides of the page. A navigation bar at the bottom of the page presents viewers with a link to past features.

The creative use of easily recognizable icons and staggered typography immerses viewers in a contemporary, MTV-like atmosphere as they navigate the site.

Project: *Barclay Web*

Design firm: Sabotage! Entertainment

Designers: Guillaume Wolf, Améziane Hammouche

Features: GIF89a animation, downloadable files

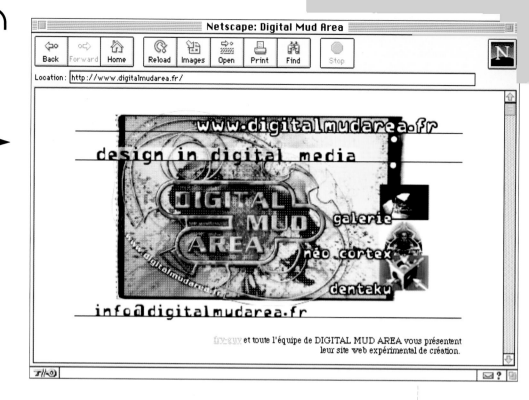

DESIGNER

The Digital Mud Area Website features the experimental design of the "Fry-Guy," Guy Grember, using English and French text throughout.

There are three different areas of the site for visitors to browse through: the "Gallery," with beautiful computer-generated images; the "Neo Cortex," where pages are linked to each other using amazing images; and "Dentaku," a link to the visual magazine *Météo*, which includes a number of reviews on current bands and music albums.

Each of these areas presents the viewer with high-quality design, typography, and computer-enhanced photography and paintings.

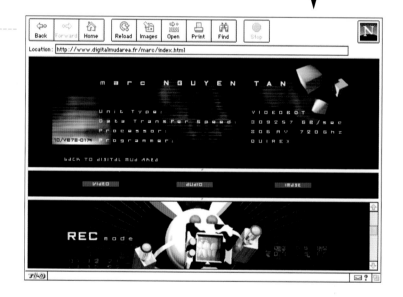

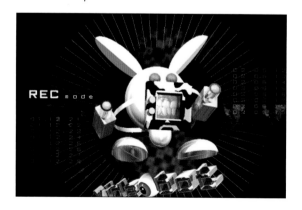

Frames are one of the main design elements used throughout the site. Using a frame divider horizontally in the middle of the pages allows the designer to incorporate a navigation bar that can be accessed no matter how small the viewer's screen, and it also gives the designer the ability to display information at the top or bottom of the page when a button is clicked.

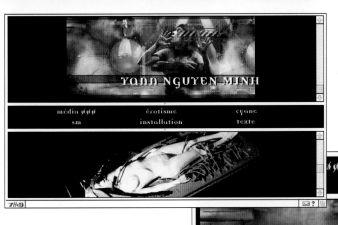

Yann Nguyen Minh's beautiful computer-generated images (at left and below) are just a small part of the Gallery section presented in the Digital Mud Area. Here, the designer creates continuity throughout the site by using the same framing technique as on previous pages.

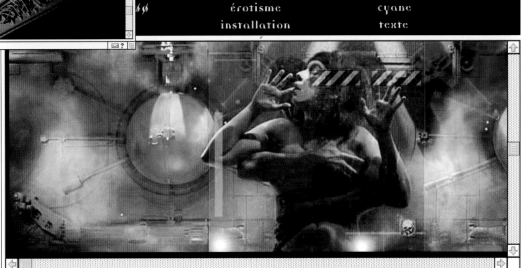

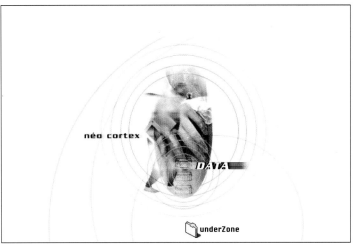

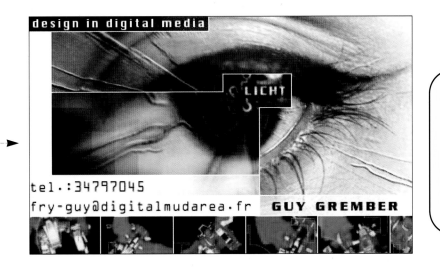

Project: Digital Mud Area

Design firm: Digital Mud Area

Designers: Guy Grember, Etienne Auger

Photographer: Agnés Pouget

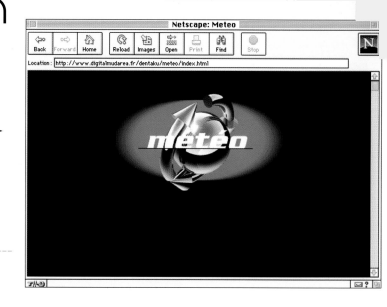

MUSIC E-ZINE

Météo/Dentaku is an international alternative music e-zine (electronic magazine) based in France. The site is accessed through the Digital Mud Area, a Website created for experimenting with various new technologies and design concepts.

Clicking on the rendered chrome *Météo* logo leads the viewer to the *Dentaku* contents page, which is the site's main navigation area.

Two of the three links on the *Dentaku* page are currently active: "Time Warp" takes the viewer to a beta contents page for the *Dentaku* 'zine, and "Critiques" leads to music critiques of contemporary bands and musicians.

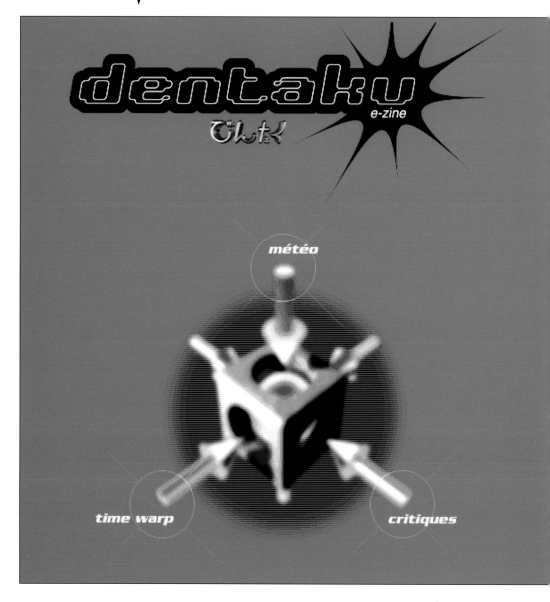

The blurry navigation cube (above) is a 3-D object set upon a very sharp 2-D background of horizontal stripes. Viewers can navigate to the "Critiques" area, to the *Météo* home page, or to the "Time Warp" area.

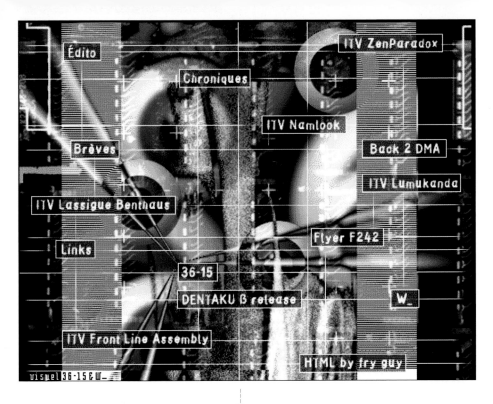

The *Dentaku* beta release contents page, above left, offers music reviews, interviews, essays, and links to other cyber-zines and music group home pages.

The "Critiques" page uses frames, in which "Fry-Guy" Guy Grember experiments with many of his designs. The split page with a navigation bar in the middle offers an interesting look at how information can be organized for the viewer.

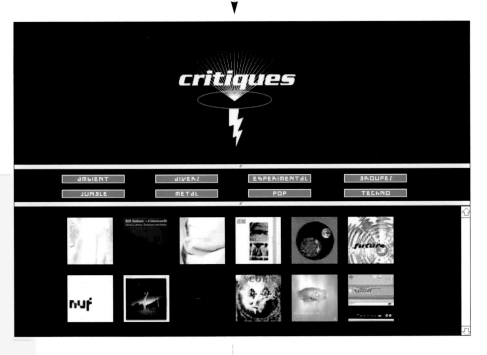

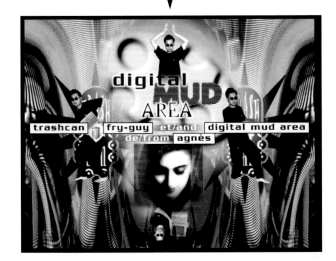

Project: *Météo/Dentaku*

Design firm: Digital Mud Area

Designers: Guy Grember, Etienne Auger

Photographer: Agnés Pouget

31

URL: http://www.sabotage.fr

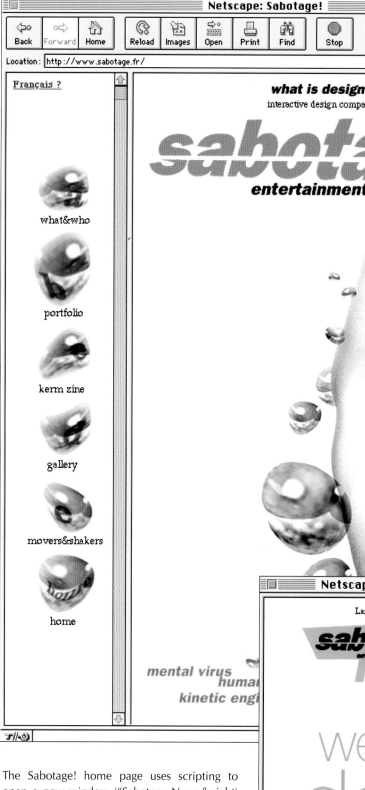

Location: http://www.sabotage.fr/

Français ?

what&who

portfolio

kerm zine

gallery

movers&shakers

home

what is design?
interactive design company

sabotage!

entertainment

mental virus
huma
kinetic eng

Netscape: Sabotage! News

Last update:19/11/96

sabotage!
entertainment

news

web
etienne
daho

C'est avec un plaisir non dissimulé que
nous sommes heureux d'annoncer
l'arrivée du Web Etienne Daho. Premier
site français entièrement dirigé par
l'artiste, ce site est l'occasion pour le
chanteur d'établir une communication
directe avec son public. C'est donc un site
vivant et régulièrement mis à jour que

SELF-PROMOTION

The Sabotage! Website is a bilingual French/English self-promotional site in France offering up a 'zine, a portfolio, an art gallery, and "Movers & Shakers," an area featuring interviews with icons of the trendy "lounge culture."

The home page utilizes a very limited color palette of various shades of green on a white background. Color is confined to the Sabotage! title and the molten lozenge links contained in the vertical frame at the left of the page—this is a technique to keep download times low, and it says a lot with a little.

The Kerm 'zine page is well-executed, again with a limited color palette. Every edge and line in the image is rough, especially the type treatment of the title, but the small photos of featured musicians and actors stand out because their colors and straight lines contrast with the rest of the design and draw the eye in.

The Sabotage! home page uses scripting to open a new window ("Sabotage News," right) that has had all of the Netscape Navigator bars turned off. Offering this design element to viewers is a great way to profile important information without cluttering up the site's design.

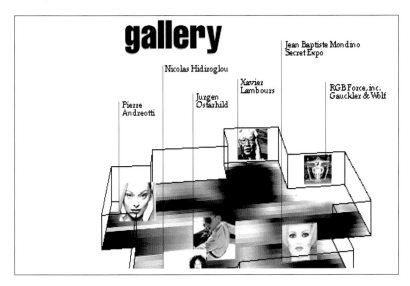

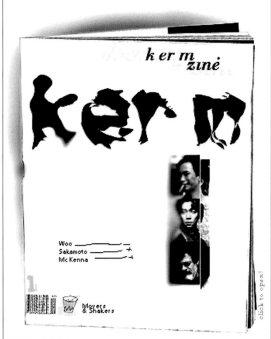

The above image is a wireframe model of the "Gallery," accessed from the home page. Notice how the innovative use of texture on the floor of the museum highlights both the color and black-and-white images.

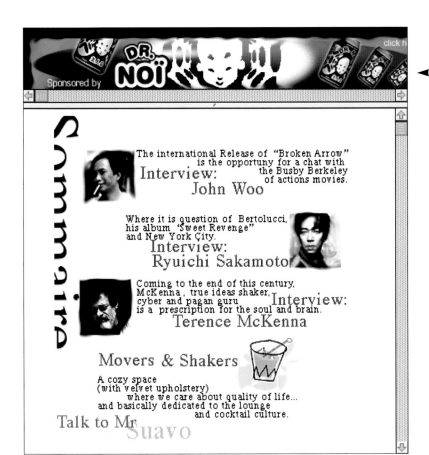

Project: Sabotage! Entertainment Website

Design firm: Sabotage! Entertainment

Conception: Guillaume Wolf, Pascal "Kerm" Forneri

Designer: Guillaume Wolf

Illustrators: Guillaume Wolf, Améziane Hammouche

Programmer: Eric "Zia" Huc

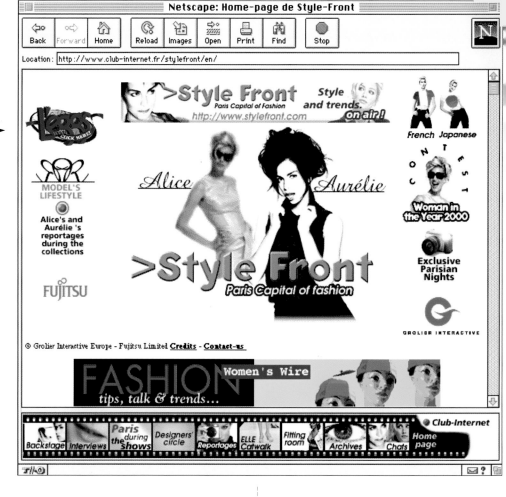

MAGAZINE

The *Style Front* site from Grolier Interactive Europe and Fujitsu Limited focuses on the styles and trends of the Paris fashion scene, complete with backstage peeks, interviews with designers, chat areas, and articles on Paris nightlife, models, and gossip.

The very cosmopolitan site allows viewers to select from Japanese, English, and French versions of the site (English and French home pages are shown at right). The busy design reflects the kinetic energy of the fashion industry and fashion reportage. The white background allows the bright colors of the fashions and icons to emerge.

The pages above demonstrate an extremely effective use of frames—the shape of a strip of film suits its long, narrow space, and is a nice complementary motif for fashion photography. Note, too, that the images in the film frames all use an earth-tone palette, evoking a warm, personable feeling. The film motif repeats in the anchor frames shown in the images at the top of the opposite page, used for pages linked to the home page.

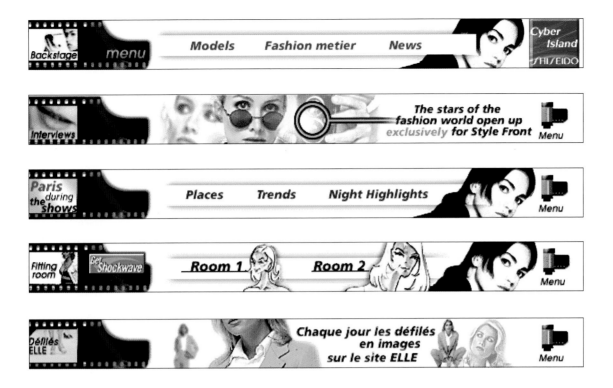

The pages to the right and below display the same two-tone background treatment that unifies all the second-level pages. The image along the top contains the same warm hues characteristic of the anchor frames.

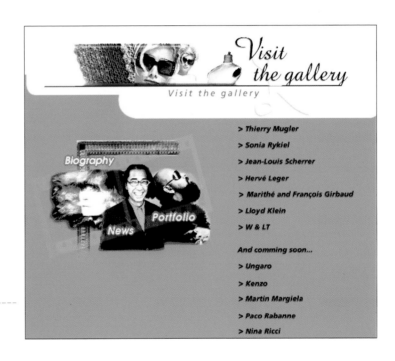

Project: *Style Front* Website

Client: Fujitsu Limited

Design firm: Grolier Interactive Europe

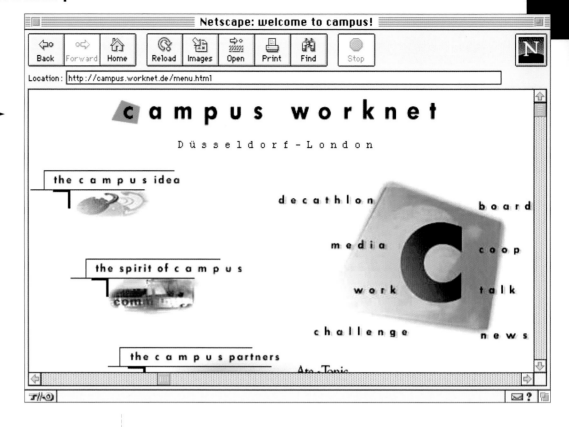

SELF-PROMOTION

Campus Worknet is a multi-national advertising firm specializing in European markets. Its pristine, organized design uses a white background, iconic use of single-color images, and consistent use of rules to highlight each page's topic.

The appearance of each page is tightly controlled—all text is generated as graphics so high quality can be maintained. Messages to viewers are given a simple typographic treatment, lightly tinted, and placed on each page to amplify headers. The limited use of color and simple white background allow for faster downloads and easier comprehension.

The home page offers access to every level of the site through image-mapping. The soft green box above has been given a gradation and a slight drop shadow, creating a sense of depth and lightness at the same time.

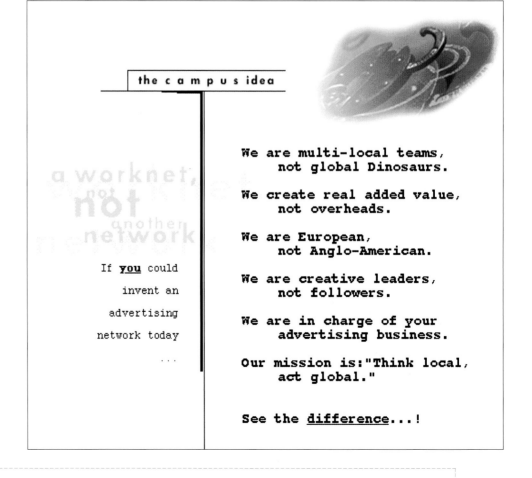

the spirit of c a m p u s

the heads are in the agencies

heads in the agencies

c a m p u s doesn't own
the agencies, the agencies
own c a m p u s.

c a m p u s is the liaison office
for the clients and the agencies.

c a m p u s has no headquarter,
the heads are in the agencies.

Every client has his lead-agency,
c a m p u s helps to lead.

t a l k

Get in contact with CAMPUS and indicat
subject in the selection box. CAMPUS s
can communicate directly by password.
Everybody else will receive immediate
feedback.

And don't forget
your e-mail address :-)

The images of the boomerang and eight-ball to the left feature an interesting shadow treatment by enlarging and blurring the objects in relation to the original. The enlarged image has a feathered shadow, again evoking a feeling of soft depth.

c o o p

With whom do we work outside the campus worknet area?

We currently develop relationships
in all other European countries.

We assigned area responsibilities
among our partners:

REMPEN & PARTNER WERBEAGENTUR
Germany, Austria, Switzerland and Eastern
Europe

WCRS
UK, Ireland and Scandinavia

Ata Tonic
Italy, Greece and Turkey

c h a l l e n g e

If **you** would like **challenge** us, please contact

Jochen Rang

Campus Advertising Ltd
Reg. No. 3121447

The London Office
41-44 Great Queen Street
London WC2B 5AR
Fon 0044-171-405 0850
Fax 0044-171-405 0845

The Düsseldorf Office
Breite Straße 13
40213 Düsseldorf

...or any of the
campus worknet agencies:

Germany
Rempen & Partner

United Kingdom
WCRS

France
Australie

Italy
Ata Tonic

Project: Campus Worknet

Design firm: WYSIWYG

Software Design GmbH

Designer: Maria Tomeczek

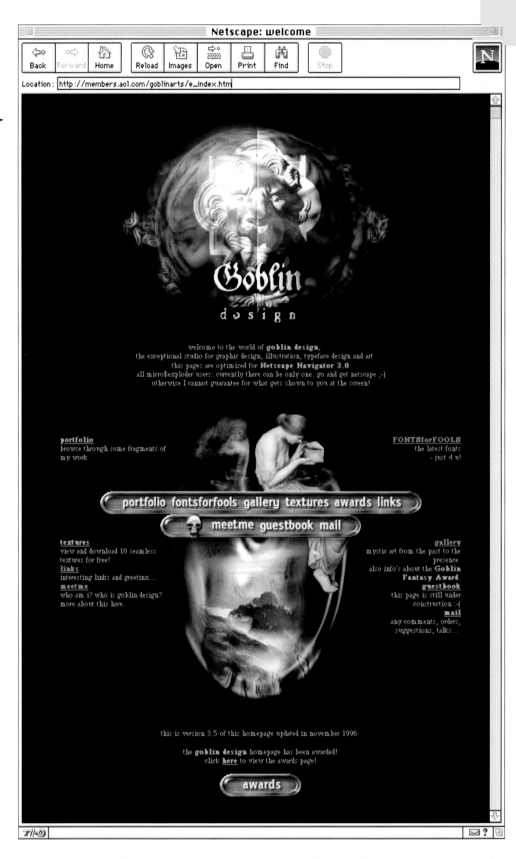

SELF-PROMOTION

The Goblin Design Website is a portfolio and promotional piece for designer and illustrator Silas Tobal. His personal challenge was to find a way to combine his "traditional fantasy art" with the technology of the Web.

To set his site apart from other portfolios on the Web, Tobal intended to make it a resource for other designers by offering downloadable files as well as a gallery of fantasy art from the past to the present.

The most unique aspect of this site is that it was initially created and hosted on the Members Web section of America Online before being moved to its current proprietary URL.

To reduce the number of levels a viewer must navigate before finding the contents page, the designer has incorporated the splash page at the top of the home page. Scrolling farther down brings the viewer to the contents screen, which includes an artfully designed navigation bar, as well as a nice layout of text blocks.

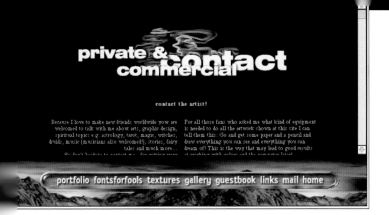

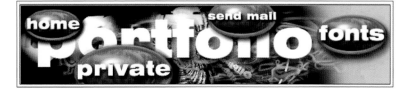

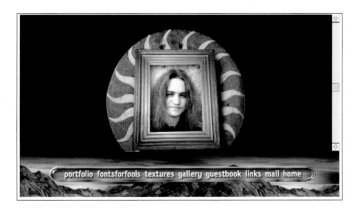

The designer shows his grasp of new Web technology by implementing frames in his designs. Using HTML scripting, the designer masks the frame borders to create the illusion of a skyline that blends into the black background of the top frame (at left and above left). Resources such as "Fonts for Fools," below, and the "Texture Test Center," at bottom, offer an added bonus for viewers and keep them returning to check out updates.

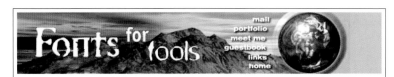

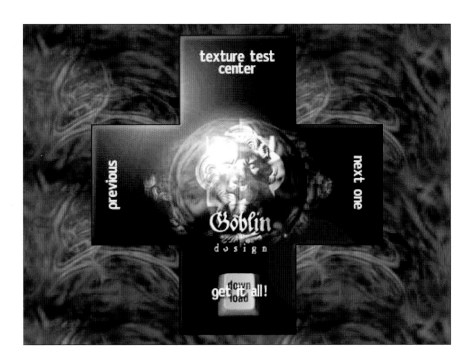

Project: Goblin Design

Design firm: Goblin Design

Designer: Silas Tobal

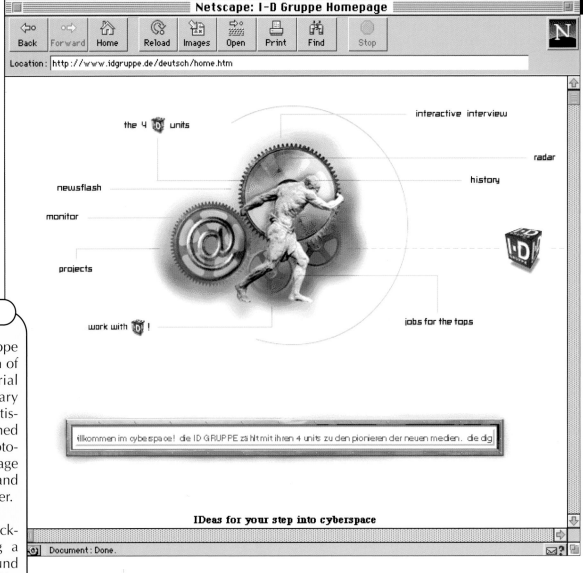

Netscape: I-D Gruppe Homepage

Location: http://www.idgruppe.de/deutsch/home.htm

the 4 units · interactive interview · radar · history · newsflash · monitor · projects · work with ! · jobs for the tops

illkommen im cyberspace! die ID GRUPPE zählt mit ihren 4 units zu den pionieren der neuen medien. die dig

IDeas for your step into cyberspace

Document: Done.

SELF-PROMOTION

The design firm ID Gruppe uses a striking combination of classic sculpture, industrial design, and contemporary typography to create an artistic and beautifully designed portfolio Website. The photo-collage on the contents page is a powerful image of art and technology working together.

Avoiding slow-loading background images and using a primarily white background helps the Website load quickly.

English titles are used for the main links to each of the site's pages, but German is used in all body copy and for descriptions (such as the "java-applets" notice on the home page).

The ID Gruppe home page uses an image-mapped graphic of rules leading to linked pages, with drop shadows for added depth. The German text in the Java-enhanced scrolling bar, above, welcomes viewers to the site: "Welcome to cyberspace! The ID GRUPPE with its four units belongs to the pioneers of new media."

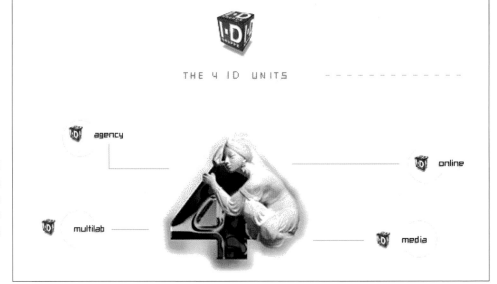

THE 4 ID UNITS

agency · online · multilab · media

White backgrounds and sparing use of images and text throughout the main navigation areas allow faster downloading of images.

Two different navigation elements are available (above left) for linking to the design group's portfolio, a Java-enhanced link, and a non-Java link. The television set displays the company's portfolio.

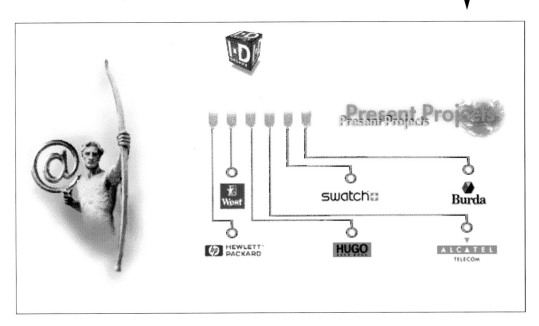

Using a circuit board design to show project links (above) and job connections (below) continues the artistic combination of classic sculpture and industrial design.

Project: ID Gruppe portfolio

Design firm: ID Gruppe

Designer: In-house

Features: Java scripting

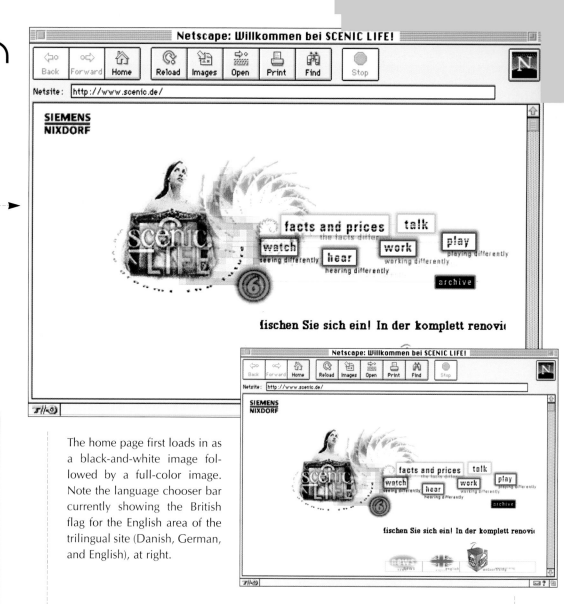

COMMERCIAL

The Scenic site promotes Scenic personal computer systems, which are popular in Europe.

The site is characterized by contemporary typography, with key words contained in shadowed boxes of different shades. The type itself appears ragged, as though sliced with a razor.

The site also features a unique menu bar on its sub-pages. Reversed-out type spells out the words "home," "watch," "hear," "work," and so forth, on a narrow, blurry, black bar— the effect is readable, though subtle.

The home page first loads in as a black-and-white image followed by a full-color image. Note the language chooser bar currently showing the British flag for the English area of the trilingual site (Danish, German, and English), at right.

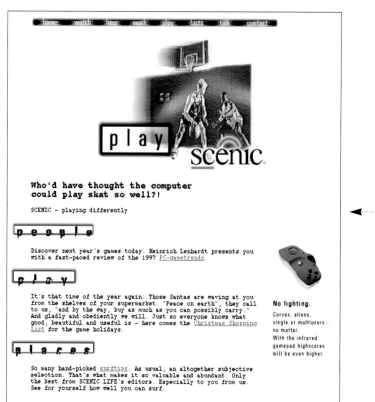

people

Discover next year's games today. Heinrich Lenhardt presents you with a fast-paced review of the 1997 PC-gametrends.

play

It's that time of the year again: Those Santas are waving at you from the shelves of your supermarket. "Peace on earth", they call to us, "and by the way, buy as much as you can possibly carry." And gladly and obediently we will. Just so everyone knows what good, beautiful and useful is - here comes the Christmas Shopping List for the game holidays.

No fighting.

Curves, aliens, single or multiusers - no matter. With the infrared gamepad highscores will be even higher.

places

So many hand-picked surftips. As usual, an altogether subjective selection. That's what makes it so valuable and abundant. Only the best from SCENIC LIFE's editors. Especially to you from us. See for yourself how well you can surf.

Once upon a time you went to work.
These days work comes to you.

Some say modern graphic design is getting worse.
That depends on how you see it.

SCENIC –seeing differently

Here are the Games!
Just in time for the holidays: The offical Christmas list by Heinrich Lenhardt, Germany's game tester. PLUS: Trade Fair feedback and trends galore.

Telephones are in!
Not yet quite ripe, but that doesn't seem to bother anyone. All the symptoms lead to a definite case of telephone mania on the WWW. So go and get yourself infected, too.

Now it's your turn!
Mix it up! You can join in the discussion in the new improved SCENIC LIFE Newsgroup. Questions? Tips? Or looking for something specific? You are at the right place here.

The site's sub-pages strive to place Scenic computer systems in a context of lifestyle, with "Scenic People," "Scenic Play," "Scenic Places," and so on.

Why SCENIC is a multimedium.

The SCENIC multimedia PC is ideal equipment for everyone. For both the professional user and the family - simply for everyone and everything. You can play with it, watch TV, listen to and make music, learn, work, telephone and fax, use online services, carry out homebanking, surf on the Internet, paint, look at photo CDs, edit videos. With SCENIC you can do anything. Plug and play makes operating easy for everyone - just plug in, switch on and off you go. The SCENIC line is a complete family of products open to infinite possibilities. SCENIC components can be combined with one another accomodating whatever personal color or working requirements you may have. And as for the future, SCENIC eqipment can be upgraded down to the last detail and according to your individual needs.

Project: Scenic Life

Client: Siemens Nixdorf AG

Design firm: WYSIWYG
 Software Design GmbH

Designer: Dirk Uhlenbrock

Programmers: Dirk Uhlenbrock,
 Knut Uhlenbrock, Siegfried
 Osterloh

Features: Java scripting

Some people go to concerts.
Others go online.

SCENIC – hearing differently.

URL: http://www.west.de

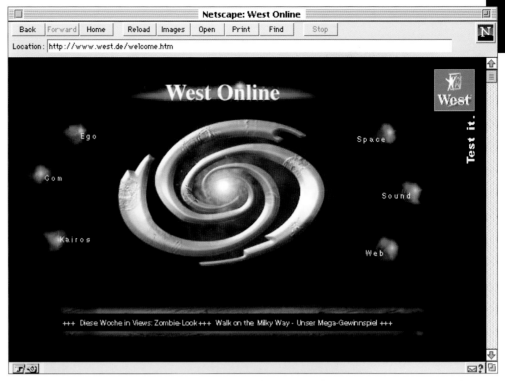

MAGAZINE

West Online is an online magazine designed by the German firm ID Gruppe. The engaging planetary or galactic motif draws viewers in with highly rendered images in rich colors placed on a black background.

Though the central image changes, the six satellites remain, but their names may change. The *West* logo appears in the upper right corner of every screen, with the characteristic red being picked up in the header as well, thus serving as a constant identifier to viewers.

The central image of the "Space" page is not a stellar body, but the image of a person's face behind the faceplate of a space suit. The subsequent page, not shown here, is of would-be astronauts experiencing weightlessness in parabolic flight.

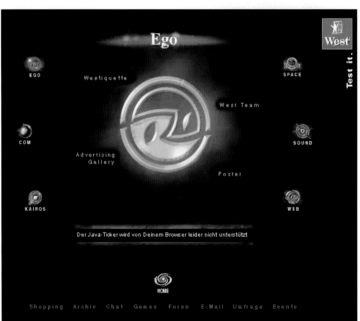

Each satellite image links to another area of the site, which is displayed as a galaxy. The "Com" area (right) is a community area featuring chat rooms and bulletin boards.

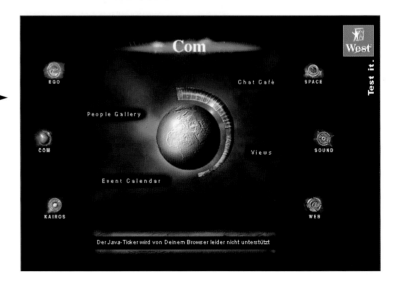

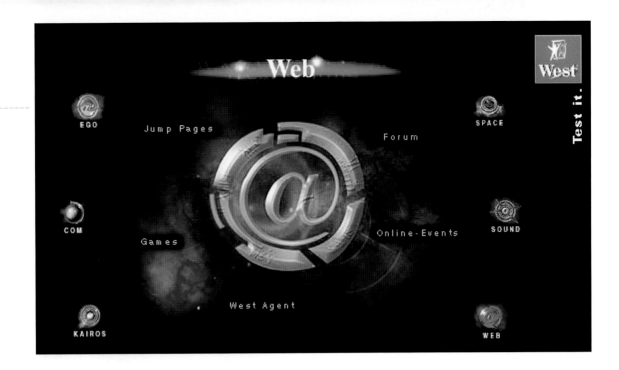

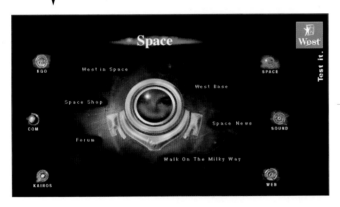

A scrolling message on the home page, (opposite page top) invites viewers to "Walk on the Milky Way," which is actually a link to a Java-scripted board game, complete with a dice roller.

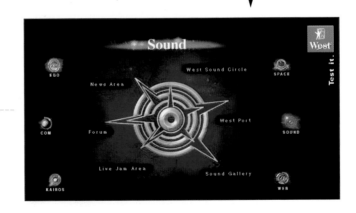

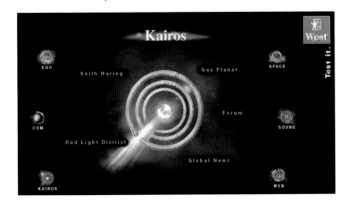

Project: *West Online*

Design firm: ID Gruppe

Designer: In-house

Features: Java scripting

Netscape: Welcome to That's Interactive Ltd- WWW

Back Forward Home Reload Images Open Print Find Sto

Location: http://www.thats.com/

WELCOME TO WWW.THATS.COM

This web site is best viewed by Using Netscape 2.0 browser. We plan to include shockwave applications and a parallel Chinese version of the same site. If you do not already have the web gadgets yet, you may choose to download them now. If you want to jump in now, click the company logo.

THAT'S INTERACTIVE LIMITED
7/FL.,206 PRINCE EDWARD ROAD WEST, KOWLOON, HONG KONG. TEL 2788-1339
E-MAIL:thats@hkstar.com
FX 2393-9090

ENTERTAINMENT

The That's It Website promotes four travel and photography CD-ROMs produced by That's Interactive, Limited, a Hong Kong–based multimedia firm. That's It promotes the CD-ROMs by anticipating questions viewers might have about the products, and replicating the CD-ROM experience on-line: showing the interface and images as they would appear on the CDs.

The site uses lively, pastel colors and a straightforward design. Highlighted tabs at the bottom of the page indicate which CD the viewer is exploring, while triangular buttons at the top allow viewers to learn more about the company, a particular disc, the interface, or the photos on the disc.

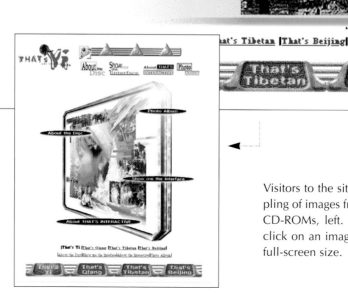

Visitors to the site can view a sampling of images from the company's CD-ROMs, left. Opposite, viewers click on an image to bring it up to full-screen size.

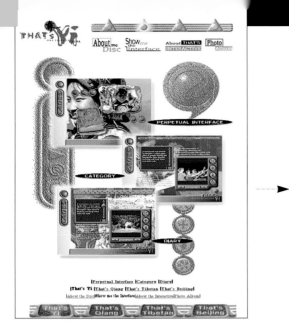

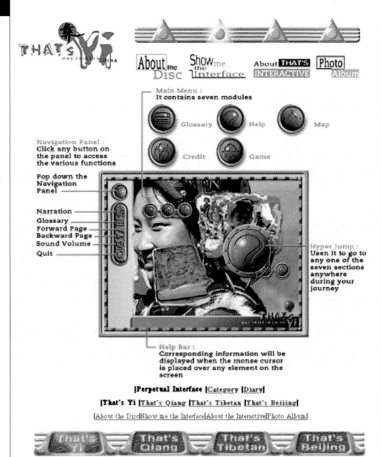

One purpose of the Website is to demonstrate the simplicity of the CD-ROM's interface. The pages above and to the right familiarize viewers with the CD-ROM's organization and navigation tools.

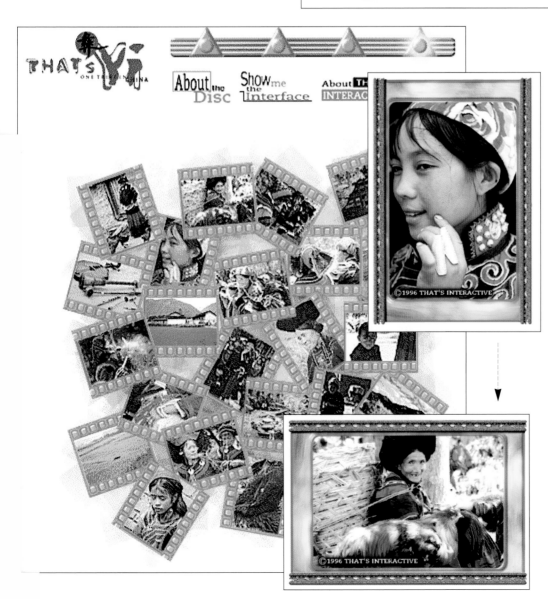

Project: That's Interactive Limited CD-ROM Promotion

Design firm: That's Interactive Limited

Editors: Hu Baoyu, Chung Lo Ming, Raymond Wan, Flavia Ho

Producer: Stephen Kam

Creative director: Rex Cheung

Designers: Foley Kwok, Joey Pun

Programmer: Canty Lee

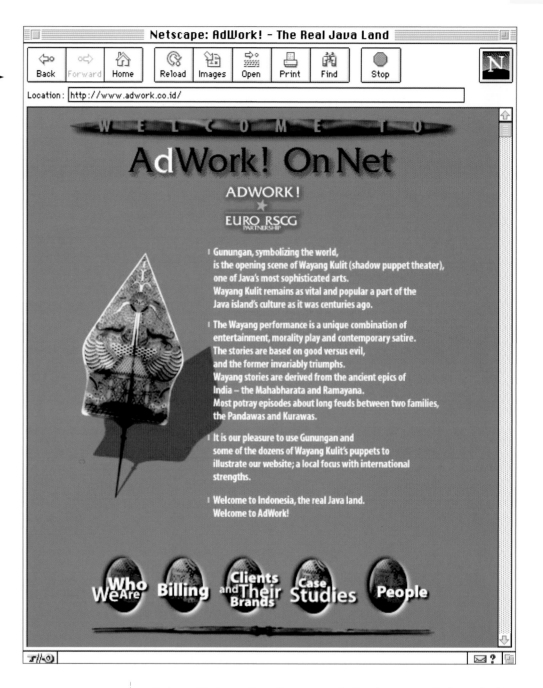

AdWork! OnNet was one of the first Indonesian advertising agencies to start up in 1988 after the government lifted a six-year ban on television advertising.

This promotional site presents case studies of AdWork's projects, a list of current clients, and background on their company and the global advertising network it's created.

AdWork! wanted their site to have a local focus with international appeal. To obtain this, they created images based on the Indonesian art of shadow puppet theater. A main image, the "Gunungan," greets viewers on the home page, and other puppet images appear throughout the site.

Embossed buttons, drop shadows on the header text, and a large shadow cast by the main image on the home page add depth to the site. As an added touch, the designers created an animated header (below) in which one letter at a time turns white sequentially.

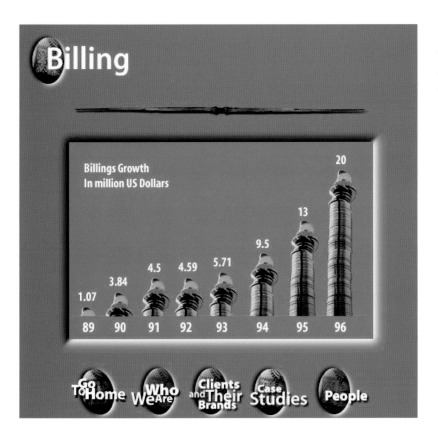

To maintain the look of the home page, bright colors are used as backgrounds for each page of the site. The designers also continued the use of embossed buttons, images, and graphs to maintain the feeling of viewing more than just a flat surface.

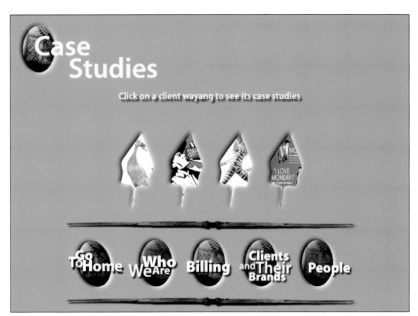

Project: AdWork! OnNet

Design firm: AdWork! Euro RSCG

Designer: In-house

URL: http://www.jer.cine.org.il

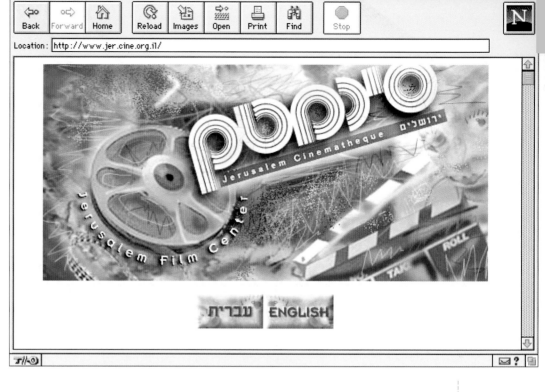

ENTERTAINMENT

The Jerusalem Cinematheque is an online resource for the film community in Israel. It features beautifully illustrated icons to represent different areas of the site—each composed around a palette of soothing blues and greens set against white backgrounds. Each incorporates some image evocative of films, such as a piece of film, a reel, or a projector.

The main image of each page appears against a freeform background of spatters, speckles, and squiggly lines, which add lightness and whimsy to the site. The basic color palette unifies the different areas of the extensive bilingual site.

The main images on each page are photomanipulated versions of photographic originals. This treatment makes them display better when optimized for the Web.

The navigational icons above are the highlight of the site, displaying intelligent creativity and whimsy in their conception. These icons are smaller versions of the illustrations used as section headers. Note that the drop shadows on the icon buttons are to the top left, rather than the bottom right, which is a common trait of American design.

Project: Jerusalem Cinematheque

Design firm: Netcreature Ltd.

Designer: Anna Ben Zakein

Illustrator: Anna Ben Zakein

Programmer: Mike Stone

URL: http://www.skee-noizz.com/home.htm

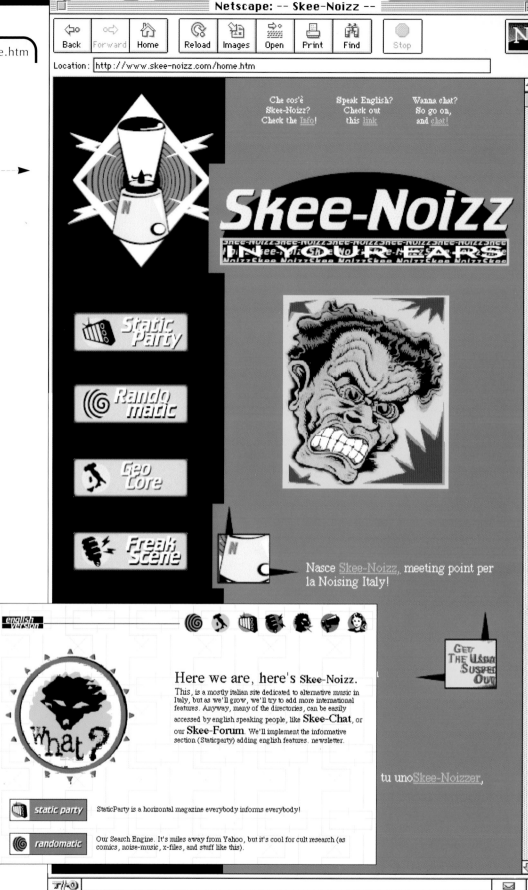

MAGAZINE

Skee-Noizz is the only domain in Italy dedicated to alternative music and culture, says the site's designer, Fabrizio Ulisse of rackEt MM.

The home page is a bright red and black vertical page featuring a garish comic book–style illustration in the center and a vertical navigation bar on the left. To contrast with the bright colors on the page, the designer uses a neutral gray on each of the main buttons.

Alternative music culture thrives on being iconoclastic, and this site promises to be "in your ears."

The site is primarily in Italian, but viewers can access a small amount of information about the site in English by clicking on a hyperlink at the top of the home page. Eventually the site will contain more international material.

Skee-Noizz uses bright, energetic color on the navigation icons and on each of the main headers throughout the site.

Each of the main header graphics includes sharp lightning bolts or jagged-edged elements, which add a dynamic quality to the overall site.

Project: *Skee-Noizz*

Design firm: rackEt MM

Designers: Fabrizio Ulisse, Francesco Panatta

Illustrator: Francesco Panatta

Programmer: Fabrizio Ulisse

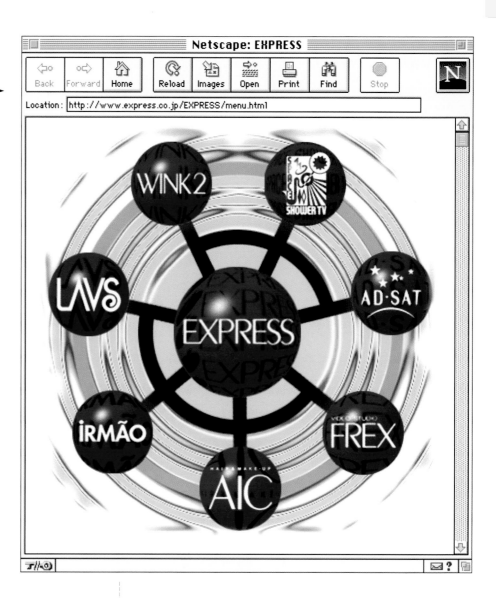

Netscape: EXPRESS

Location: http://www.express.co.jp/EXPRESS/menu.html

SELF-PROMOTION

The Express design firm of Osaka, Japan, has created a uniquely dynamic interface for accessing online content. Its home page uses a wheel-like layout to present links to seven clients. The background of the layout resembles ripples on the surface of a pond, which draw the eye outward toward seven spheres.

Text mapped to the spheres and added highlights provide a strong sense of dimensionality on an otherwise flat screen.

The home page (above) features a large image-mapped graphic that loads quickly because of its minimal palette. Circular images are an important element throughout the site. Each page features some form of the sphere, adding continuity throughout.

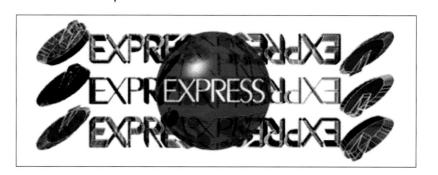

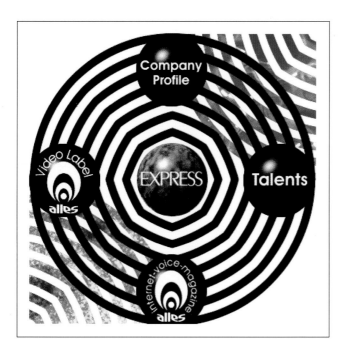

A basic palette of red, blue, and green forms the main color scheme for this site. The designers used very few photographic images—they chose instead to use simple schematic images to present the navigational structure.

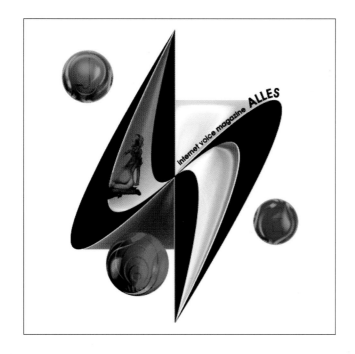

Project: Express

Design firm: Express Co. Ltd

Designer: Masayoshi Kimura

URL: http://express.co.jp/ALLES/index.html

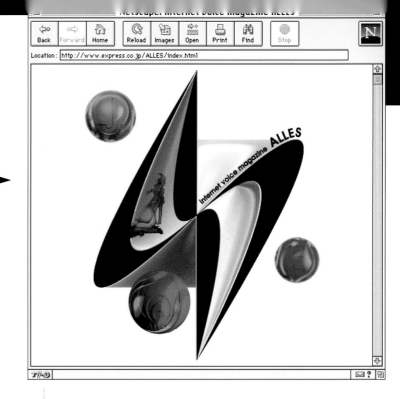

MAGAZINE

The word "alles" means "everything" in German. *Alles*, "the Internet Voice Magazine," lives up to its name by offering viewers a range of content to peruse in sports, music, art, movies, and fashion. The main focus of each issue of *Alles* is an interview with various trend-setters who create Japanese pop culture.

The splash page for *Alles* offers viewers Japanese or English navigation through the bilingual site.

A white background and strong, uncluttered design with ample white space evokes a sharp, clean feel.

The images on each page orient around a vertical graphic of the *Alles* logo. This bar serves as a strong design element that counterbalances other graphic elements.

Viewers can access back issues of *Alles* in the "Interview Archive" area. Each issue of *Alles* incorporates a different splash page representing creative variations on a theme. Note how each layout incorporates the *Alles* logo, volume, and month information, as well as a choice of Japanese or English navigation.

Project: *Alles*: Internet Voice Magazine

Design firm: Express Co. Ltd.

Designer: Masayoshi Kimura

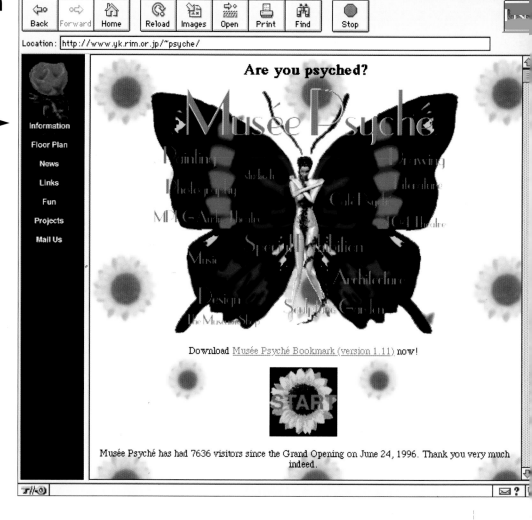

ENTERTAINMENT

Musée Psyché introduces viewers to the work of what the site's designer, Kenji Saito, refers to as "offbeat digital art."

The site features exhibitions that include painting, photography, literature, and aural art forms. Each exhibit features its own unique design, such as "Memoirs of My Body," which features a front and back image of a female body and represents an anatomy study chart.

The overall structure and appearance of the site resembles a gallery, with each of the main exhibits residing on one of the three floors or the basement level.

The opening page of the site lists the contents of the site on top of the image-mapped butterfly woman, preparing the viewer for the interesting and unique designs found within the site. The designer uses many advanced design elements in the site, including RealAudio, GIF89a animation (the sunflower on the home page), and various Web audio formats.

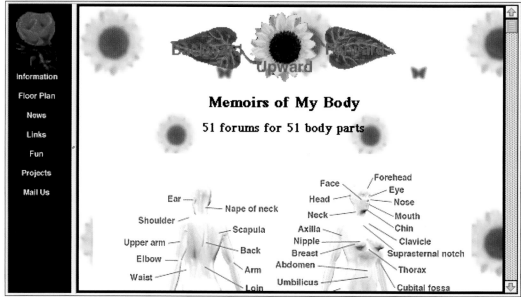

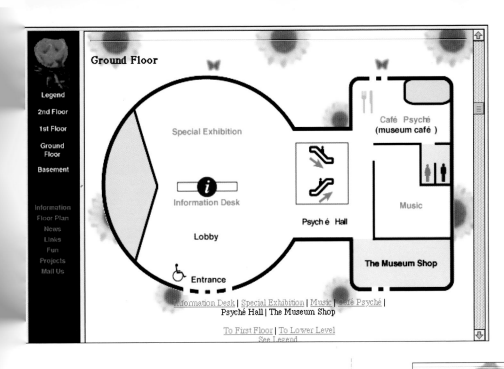

Ground Floor

Legend
2nd Floor
1st Floor
Ground Floor
Basement

Information
Floor Plan
News
Links
Fun
Projects
Mail Us

Special Exhibition

Information Desk

Lobby

Entrance

Café Psyché
(museum café)

Music

Psyché Hall

The Museum Shop

Information Desk | Special Exhibition | Music | Café Psyché |
Psyché Hall | The Museum Shop

To First Floor | To Lower Level
See Legend

Shown at left is a navigational floor plan for the Musée Psyché virtual gallery and museum, including a gift shop, café, music area, and wheel-chair access.

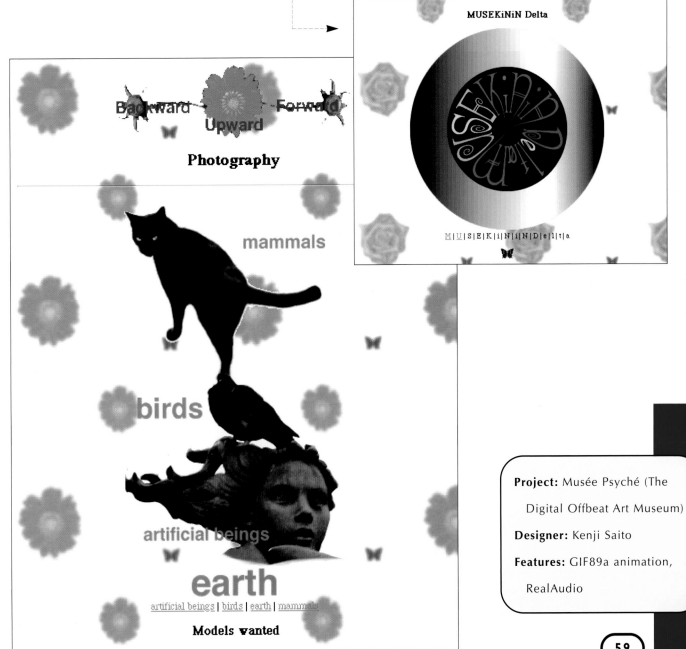

Backward Forward
Upward

Photography

MUSEKiNiN Delta

M | U | S | E | K | i | N | i | N | D | e | l | t | a

mammals

birds

artificial beings

earth

artificial beings | birds | earth | mammals

Models wanted

Project: Musée Psyché (The Digital Offbeat Art Museum)
Designer: Kenji Saito
Features: GIF89a animation, RealAudio

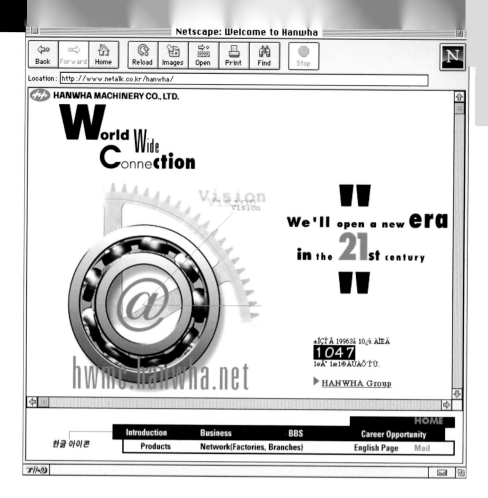

The Hanwha Machinery Company site is an example of clean, well-executed industrial efficiency for the Korean manufacturing company.

Bold, easy-to-read typography and a simple color scheme characterize the site. The large quotation marks are particularly eye-catching. Gleaming industrial images of gears and bearings accent the main frames, evoking a sense of strength and accuracy.

The Website features general information about Hanwha's manufacturing capabilities, as well as employment information, a guest book, and information about subsidiary companies.

Designers at NeTalk use frames technology to optimize download time and viewer navigation. The navigation bar (above) loads into the smaller frame once and remains constant while images in the larger main frame change.

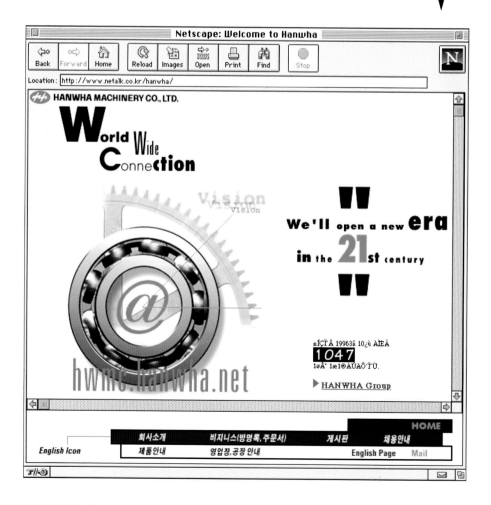

[All about HWMC]

About HWMC

Products

Introduce Subsidia·y Company

" Go! Wanted! you 모집 사원 Hanwha Machinery "

Creative typography is a hallmark of the Hanwha site. Each page features artistically designed typographical layouts, combined with illustration and photography.

The English pages of the Hanwha site (right) feature only English type treatments, whereas the Japanese pages feature both English and Japanese type creatively designed into the layouts (top right).

HANWHA MACHINERY CO., LTD.

All About Company
└──All About Company

" We'll open a new **era** in the **21**st century "

[All about HWMC]

About HWMC

Products

Introduce Subsidiary Company

HANWHA MACHINERY CO., LTD.

BBS
└──BBS

[**Meet** He**ar** **Feel** **Ta**lk sp**eak**]

[**C**ontact **Us**]
Guest Book **Order** Form

Project: Hanwha Machinery

Client: Hanwha Corporation

Design firm: NeTalk Inc.

Designers: Mina Kang,
Bae Sung Hoo, Min Hae Won

Illustrator: Mina Kang

Programmer: Hui Kim

Photographer: Jun Young Kim

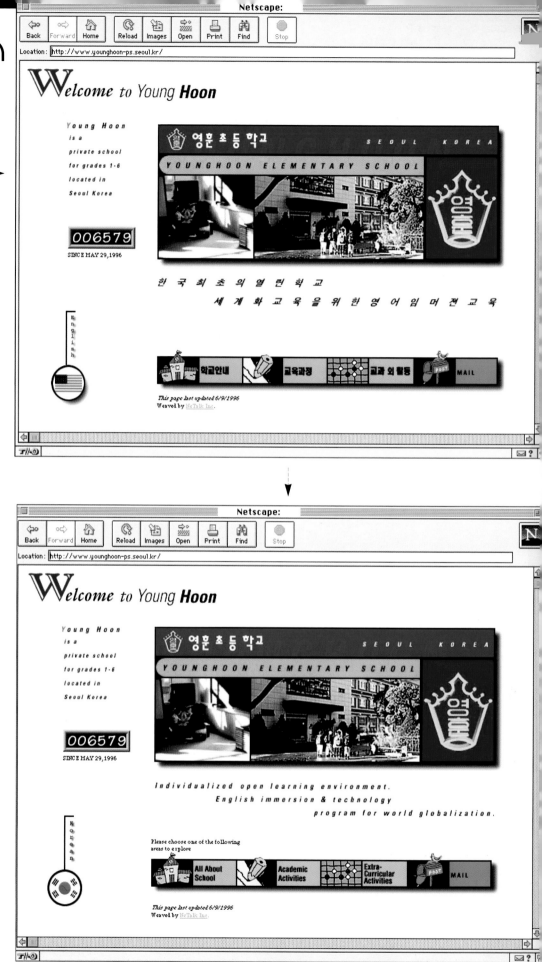

EDUCATIONAL

The Young Hoon Elementary School Website is an online presence for a private elementary school in Seoul, South Korea. According to the designers, it is also a platform to allow students and teachers at the school to operate outside physical boundaries.

A simple color palette, white background, and rectangular design elements come together to evoke an image of professionalism and success—hallmarks of private learning academies the world over.

The school curriculum features English-language immersion, so the site is bilingually well integrated with parallel Korean and English elements indicated by the same illustrative icons.

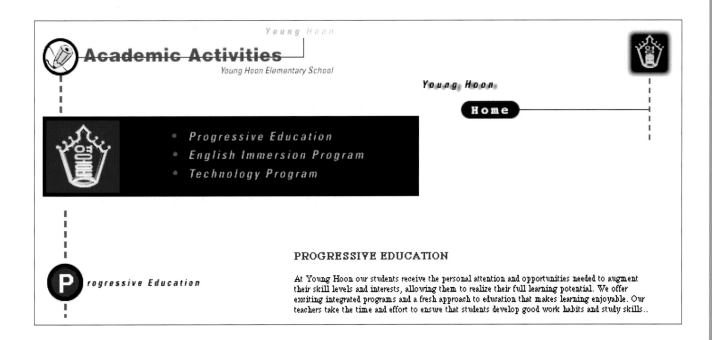

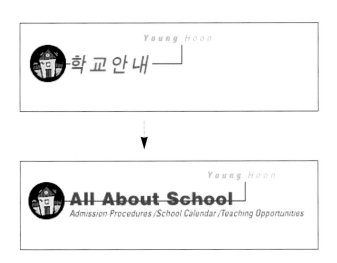

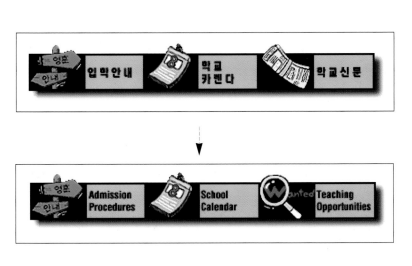

Project: Young Hoon School

Design firm: NeTalk Inc.

Designers: Mina Kang,

Bae Sung Hoo

Illustrator: Mina Kang

Photographer: Jun Young Kim

Programmers: Hui Ki Kim,

Soo Min Park

Colored rules lend structure to the expansive white spaces of the site's pages. Icons from the home page navigation bar (pencil and schoolhouse) are carried over as circular icons on sub-pages.

URL: http://www.jaring.my/bte/hardrock/

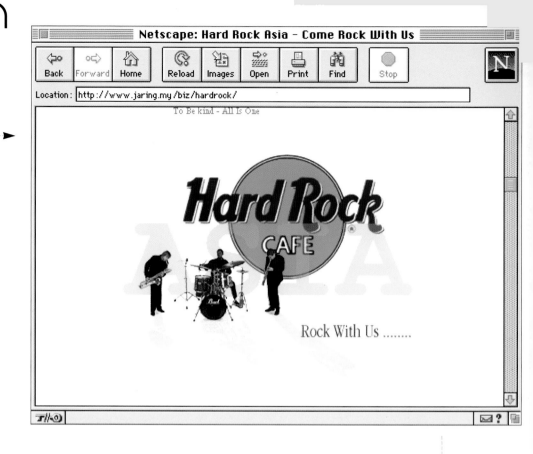

To Be kind - All Is One

Rock With Us

COMMERCIAL

The Hard Rock Cafe (an international chain of trendy retro diners) can be found in many of the world's largest cities. The Hard Rock Cafe: Singapore greets viewers with a splash page that immediately brands the site as residing in Asia. The large logo invites visitors to "Rock With Us...." A rock band icon sets the tone of the site and leads to a graphical, icon-based contents page.

The contents page continues the music theme from the splash page and presents a fun and engagingly retro design carried throughout the Website.

The typefaces used on each page complement the retro illustrations used on the main headings and add a fun, party-like element to the overall design.

Hard Rock Cafe Singapore - Key Personnel

Hi my name is Adeline and welcome to Hard Rock Cafe Singapore! It's a good idea to be on the Net so that everyone around the world can exchange ideas and get to know one another better. After all, **ALL IS ONE** right? So if you have any questions or suggestions, email to me and I'll be glad to answer them. At Hard Rock Cafe, we always **TAKE TIME TO BE KIND** and do our very best to **LOVE ALL SERVE ALL**!

The creative use of white space and multiple sizes in the heading typography keep the sparse pages from becoming stagnant or boring.

Project: Hard Rock Cafe: Singapore

Design firm: Beta Interactive Services

Designers: Belinda Chew, Adrian Reitberg

Illustrators: Suzanna Ng, Paul Pok

Programmer: Belinda Chew

Features: GIF89a animation

The minimal color palette used throughout the site allows a quick download of each page. Using a white background makes it easy to place images against the background and ensures that they will look the same on different browsers.

SELF-PROMOTION

Kristian Esser's portfolio greets the user with a spinning GIF89a animation. As the black logo spins, a gray shadow follows the movement, giving remarkable depth to the image. White space, typography, and imagery combine to focus the eye on the main navigation image.

The underside of a pill capsule holder is the main navigation element on the contents page. Clicking on an empty capsule bubble links the visitor to different portfolio pieces. The pill theme continues throughout the portfolio pages.

A stark white background allows the designer to focus the user's attention on the images, and drop shadows on various elements give added depth to the interface.

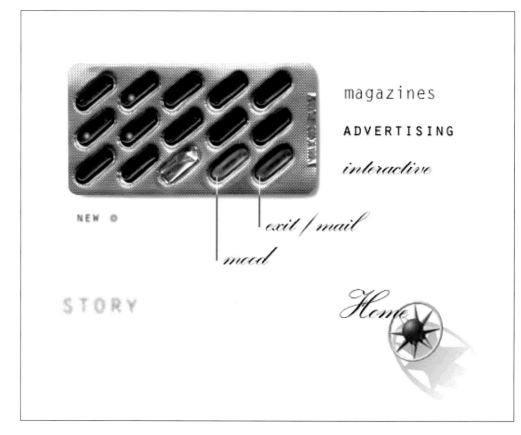

The main contents page—a partly empty capsule bubble-pack—contains links to the designer's portfolio pages. In the left corner (above) an animated GIF89a continuously loops, displaying a quote one word at a time until the user clicks on a link.

CONCEPT
ILLUSTRATION
DESIGN

a

Blurred capsules and text at the top and bottom of the page (above) work to attract attention to the main portfolio images. Drop shadows on the portfolio image and "Back" button create the illusion of depth. The designer uses elegant type design and interesting layouts and imagery to show off his design ability and proficiency in using graphic design tools (below).

Project: Kristian Esser

 Portfolio

Designer: Kristian Esser

Programmers: Kristian Esser,

 Chidi Onwuka

Features: GIF89a animation

URL: http://nethost.whanganui.ac.nz/~ctamahor

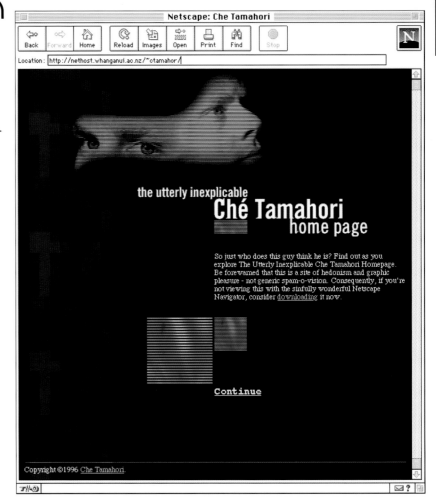

SELF-PROMOTION

Ché Tamahori's Website is both a portfolio and a personal experiment in Web page design. His site is divided into two areas: his "Obsessions" and his "Portfolio."

"Obsessions" presents viewers with a number of Macintosh-related resources and links to designers and design-related sites. The "Portfolio" area focuses on the "Musée," a gallery of creative arts that grew out of a school project.

The beautifully designed site presents images and typography on a black background with a blurred gray-blue side bar that adds contrast to the black and serves as a design element against which to place headers.

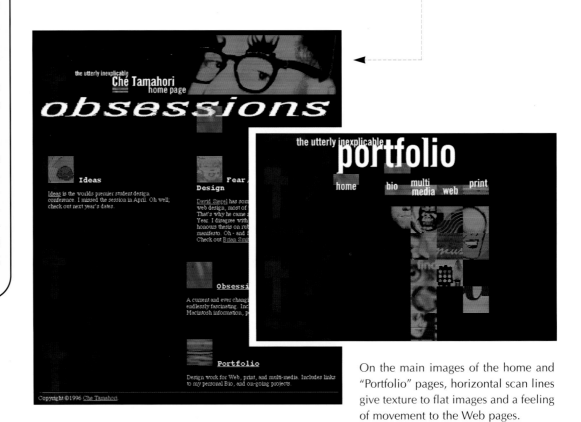

On the main images of the home and "Portfolio" pages, horizontal scan lines give texture to flat images and a feeling of movement to the Web pages.

The "Musée" gallery showcases two areas: the typography of designer Brian Smith (bottom), and a fashion design graduate show (below) featured in a horizontally scrolling page the designer refers to as "Web-o-Rama." The typographic area presents typefaces designed by Smith in the same horizontally scrolling page. This unique and interesting element works well with both gallery designs.

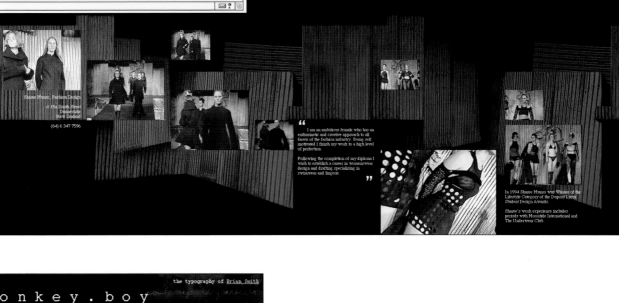

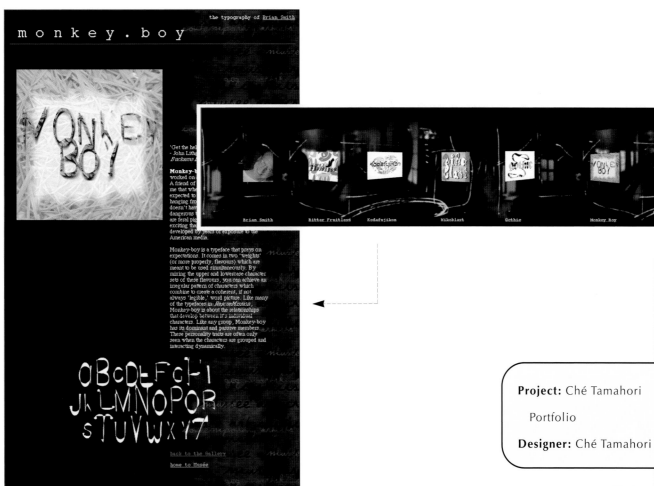

Project: Ché Tamahori
Portfolio

Designer: Ché Tamahori

URL: http://www.mogul.no

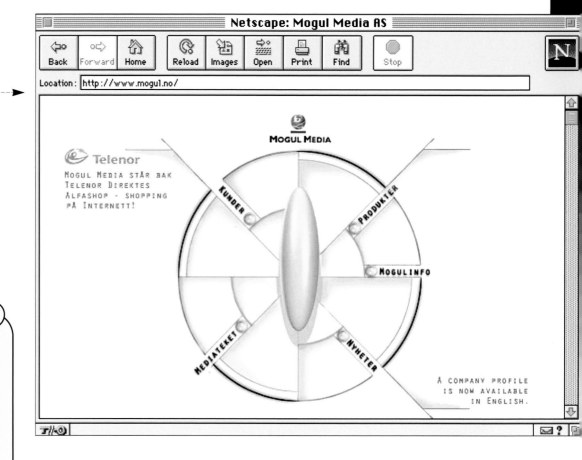

Mogul Media is a multimedia production company in Oslo, Norway. The company's vision is to become a major provider of interactive services and multimedia solutions.

Unlike the headlines of other non-English Websites, Mogul Media's headlines are only in their native language, although they have added a company profile in English that is accessible through the home page.

The interesting circular graphic on the home page links to the five main areas of their site: "Kunder" (new), "Mediateket" (media kit), "Nyheter" (new), "Mogul-info" (information), and "Produkter" (products).

Mogul Media carries its contemporary design into its clients' pages, as can be seen in the Ricco Vero Website (opposite page).

The home page graphic is the only large image used throughout the site. A half-size version of the image has been reworked to include all five navigation buttons. To show viewers where they are within the site, the designers displayed the header next to a bullet that continues the color and look of the main graphic.

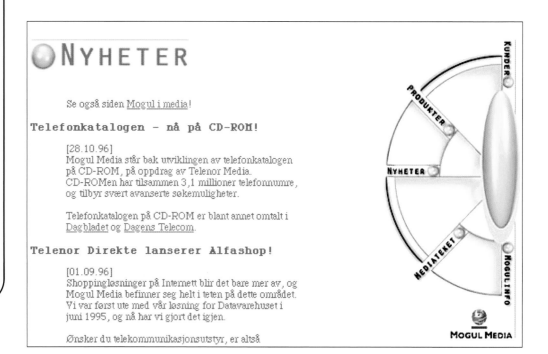

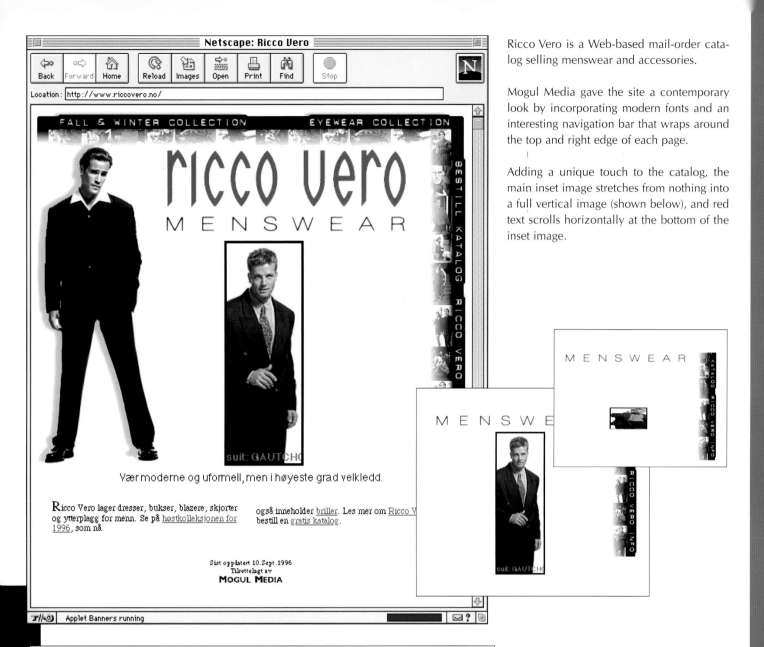

Ricco Vero is a Web-based mail-order cata-
log selling menswear and accessories.

Mogul Media gave the site a contemporary
look by incorporating modern fonts and an
interesting navigation bar that wraps around
the top and right edge of each page.

Adding a unique touch to the catalog, the
main inset image stretches from nothing into
a full vertical image (shown below), and red
text scrolls horizontally at the bottom of the
inset image.

Project: Mogul Media,
Ricco Vero

Client: Ricco Vero

Design firm: Mogul Media

Designer: Piotr Ryczko

Programmers: Anboørn Grindneim,
Thomas Flemming

Photographer: Morten Quale

71

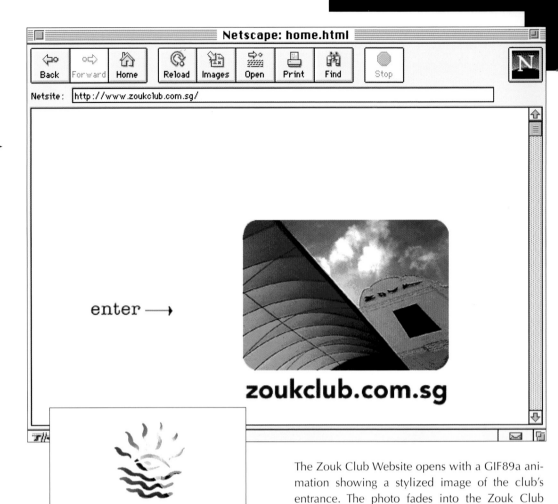

COMMERCIAL

Zoukclub.com is an online presence for a dance and music club in Singapore.

GIF89a animations add motion and energy to this site dedicated to the alternative club scene. The image-mapped table of contents features small GIF89a animated icons for each category: the eye blinks, the mouth opens and closes, the letter "i" becomes a question mark, and so on. When a visitor goes to one of these areas, the ellipse fills with blue and gold to indicate the viewer's present location. The animated icon also reappears, again as a GIF89a animation.

The Zouk Club Website opens with a GIF89a animation showing a stylized image of the club's entrance. The photo fades into the Zouk Club logo, which masks the photo.

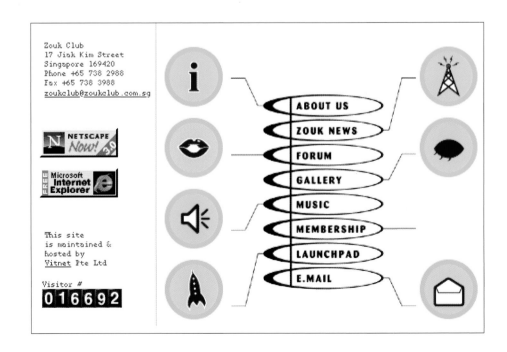

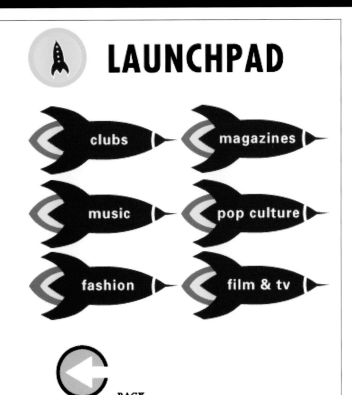

LAUNCHPAD

clubs | magazines

music | pop culture

fashion | film & tv

BACK

The "Launchpad" (left) allows viewers to access articles and reviews on a number of topics. The colorful rockets are actually GIF89a animations, sporting flickering exhaust flames.

The Zouk Club Website also features a "Flyer Archive" of cutting-edge flyers used to advertise rave parties held at the club (below).

ABOUT US
ZOUK NEWS
FORUM
GALLERY
MUSIC
MEMBERSHIP
LAUNCHPAD
E.MAIL

ZOUK RESIDENT DJS

MUSIC

Dance music over the past few years has been slowly but surely making its mark in Singapore. Although not as massive as its counterparts in Europe and the States, it is evident that dance music is making inroads into the mainstream music scene.

Turn on the radio and one out of every five songs, one is bound to be a dance track or remix.

New dance clubs are opening up, and dance groups are being formed.

Record companies are devoting more time and money to promote the music, and CD shops are allocating more space to dance products.

The whole industry is no longer ignoring this trend in music tastes. Not bad for a city of 2.6 million people who are more into karaoke than cutting edge dance.

More importantly, today's youth/pop culture has taken its roots in the dance music movement. Fashion, icons, the media, entertainment and the way we think, have all

ABOUT US
ZOUK NEWS
FORUM
GALLERY
MUSIC
MEMBERSHIP
LAUNCHPAD
E.MAIL

FLYER ARCHIVE

Project: Zouk Club Singapore

Client: Zouk Management Pte, Ltd.

Design firm: In-house

Designer: Robert Upton

Programmers: Shawn Chin, Vitnet Pte. Ltd.

Features: GIF89a animation

URL: http://www.electric.co.za

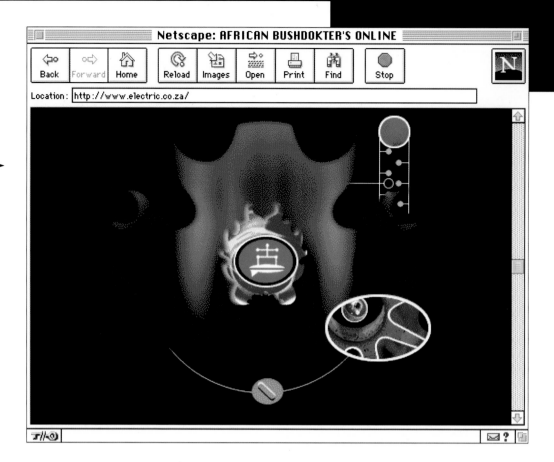

Netscape: AFRICAN BUSHDOKTER'S ONLINE

Back | Forward | Home | Reload | Images | Open | Print | Find | Stop

Location: http://www.electric.co.za/

SELF-PROMOTION

Electric Ocean's portfolio Website begins with a unique, invitingly illustrated splash page. There is no text, only a blinking red animated GIF circle at the top right and an inset eyeball graphic that foreshadows the contents page illustration.

The contents page is just as simplistic as the splash page. Only four links lead from this page: (right) to "contact" information, "hype" about the company's various projects, a "clients" page, and a biographical page.

It's this simplicity combined with the beautifully rendered graphics that draws the viewer into the site.

The color scheme works well with the black background, and images are optimized for quick download, without being overly compressed and pixellated.

As the contents page image loads, an eyeball icon (see series at right, and inset image above) floats out of the star image and comes forward toward the viewer, looping until the viewer clicks to check out another page.

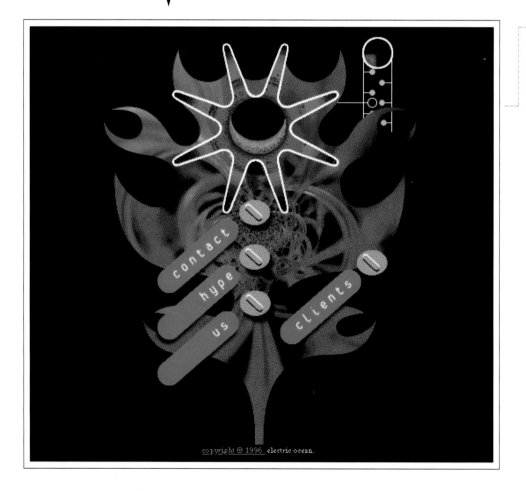

copyright © 1996, electric ocean.

The site uses a basic color palette throughout, and images are kept small for optimal downloading. The only text presented on the site is in the "hype" section, where the many awards the design studio has won are listed as HTML text, along with links to the corresponding projects.

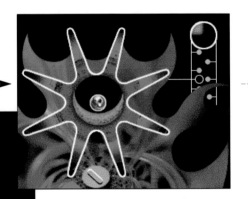 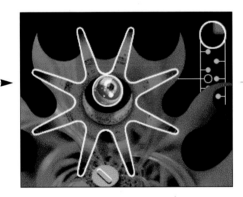 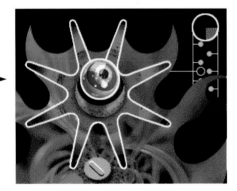

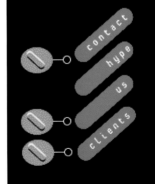

STUDIO ONE AWARD *(Internet Professional Publishers Association)*
"After an in-depth review, your studio has been selected for the IPPA's StudioONE Award, saluting the finest advertising and Web design agencies working on the Internet today. The StudioONE Award focuses corporate interest on quality design agencies, increases the marketing potential of those agencies, and serves to honor and reward quality work by directly recognizing the individual agencies rather than strictly a few of their best sites."
Thomas Van Hare, president of the IPPA

IPPA
studioONE

LOERIE AWARDS (South Africa) June 10 1996.
"Electric Ocean (1996 Loerie winner in the promotional marketing category) wins the first major ad award for a net site. "

Project: Electric Ocean
 Portfolio
Design firm: Electric Ocean
Designer: Nicholas Wittenberg
Illustrator: Nicholas Wittenberg
Programmer: Stephen Garratt
Features: GIF89a animation

URL: http://www.aztec.co.za/users/cococo/index.html

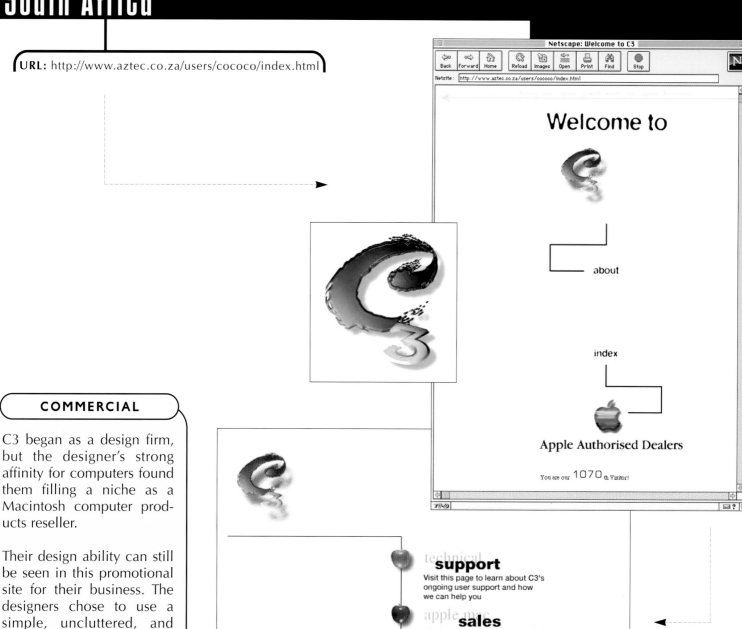

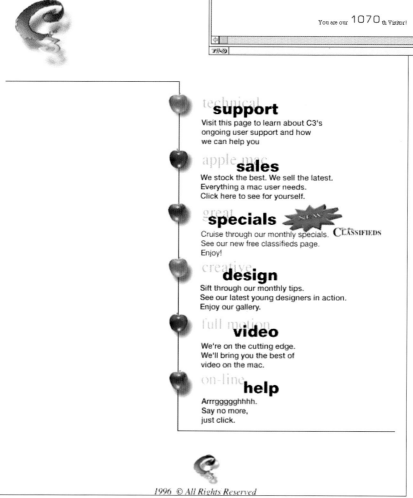

COMMERCIAL

C3 began as a design firm, but the designer's strong affinity for computers found them filling a niche as a Macintosh computer products reseller.

Their design ability can still be seen in this promotional site for their business. The designers chose to use a simple, uncluttered, and easily updatable layout to showcase their products and services.

A white background helps keep download time to a minimum, and lines direct the viewer's eye toward the important areas of the site.

Drop shadows behind the apple icons and layered, screened-back type draw the viewer's eye toward the middle of the page while adding depth and movement to the Website.

C3 gives visitors to its site a reason to return regularly by offering more than just products. Video tips and tricks, samples of various video formats, and links to other relevant Websites make the site a valuable resource for the designer who has purchased or is planning to purchase a computer or peripheral.

Project: C3

Design firm: C3

Designers: Garren James, Reto Reolon

Illustrators: Garren James, Reto Reolon

Programmers: Garren James, Reto Reolon

Features: GIF89a animation

URL: http://www.electric.co.za/gunston500/index.html

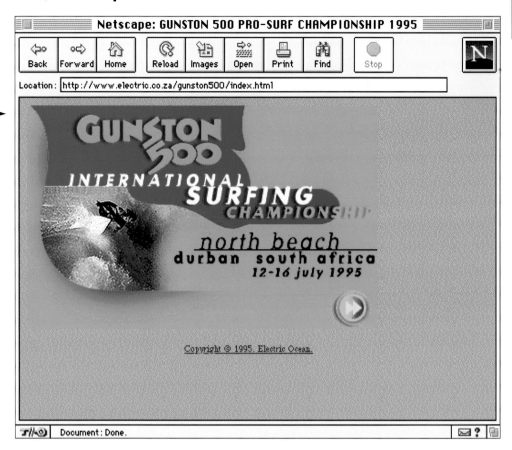

ENTERTAINMENT

The Gunston 500 site was created to feature the 1995 International Surfing Championship in Durban, South Africa, but it continues as a Web resource for professional and amateur surfers.

The designers used a limited color palette for this site, choosing a bright orange for the main background color and an ocean green for all of the navigation bars. As an interesting twist, the designers used a right-sided light source, casting the shadows to the left (rather than the traditional right) side of each graphic.

The logo features rounded, cut-away edges that contrast with the sharp, square edges of browser windows.

This site is an example of how designers need to be aware of differences in color palettes from one computer system to another. Cropping the images as square color blocks can show the differences between optimizations on backgrounds and images (such as the main logo on the home page above and the rounded buttons on the facing page at top). Using a Web design tool such as the Photoshop "PhotoGIF" plug-in to make the image backgrounds transparent would solve this problem.

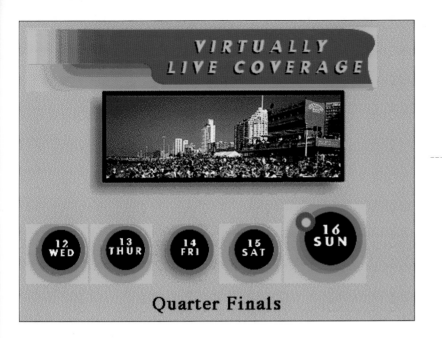

Stylized button bars featuring various curved edges, along with gradations that fade into the orange background, maintain continuity with the home page.

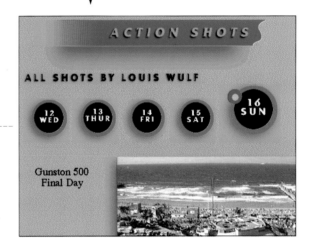

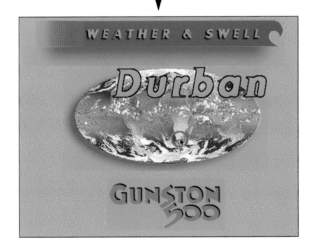

Project: Gunston 500

Design firm: Electric Ocean

Designer: Nicholas Littenburg

Illustrator: Nicholas Littenburg

Programmers: Stephen Garratt, Quentin George

URL: http://www.leisureplan.com

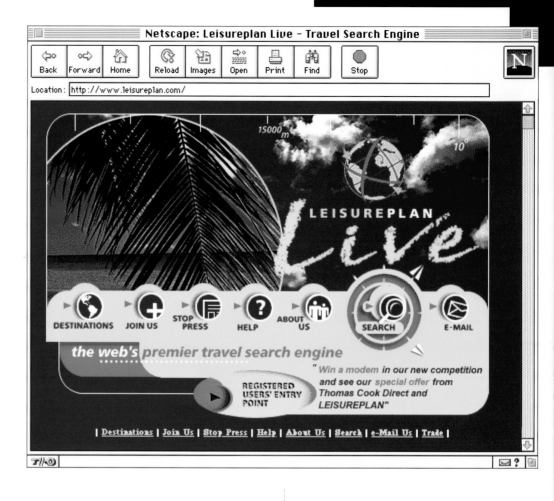

COMMERCIAL

Leisureplan Live is one of the most unique travel-related sites on the Web. While most travel sites focus primarily on content, letting the images and text control the design, Leisureplan Live has found a way to combine both content and design in a beautiful and interesting interface.

Drop shadows throughout the Website give a multilayered look to the design, as seen in the buttons on the home page and the tabbed, layered navigation bar.

To contrast with the sharp edges of the browser window, rounded corners were used on the image-mapped home page graphic and all of the navigation buttons.

Bright, flat colors in the backgrounds and buttons make for easier optimization and faster download time. The designers chose the blue of the background to match the ocean color on the home page and carried the color scheme throughout the site, adding a fun, lively look.

To help viewers keep track of which country or continent they are visiting, the designers color-coded the buttons with flags of each area, prominently featuring the flags next to the country names. To feature the photographic tour of each area, the designers used recognizable icons such as the slide images at right, continuing the rounded edge element.

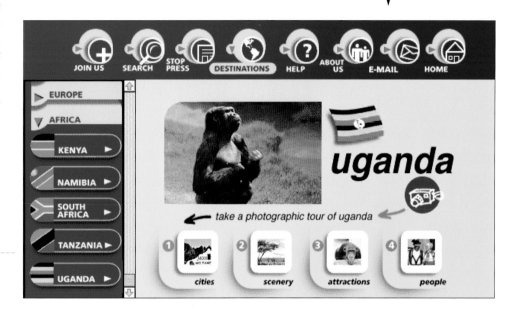

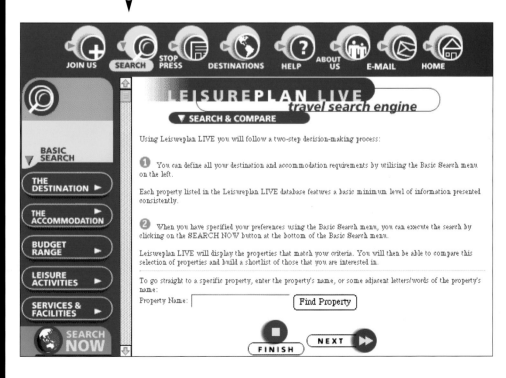

Project: Leisureplan Live

Design firm: Electric Ocean

Designer: Nicholas Littenburg

Illustrator: Nicholas Littenburg

Programmers: Stephen Garratt, Quentin George

URL: http://www.teknoland.es/

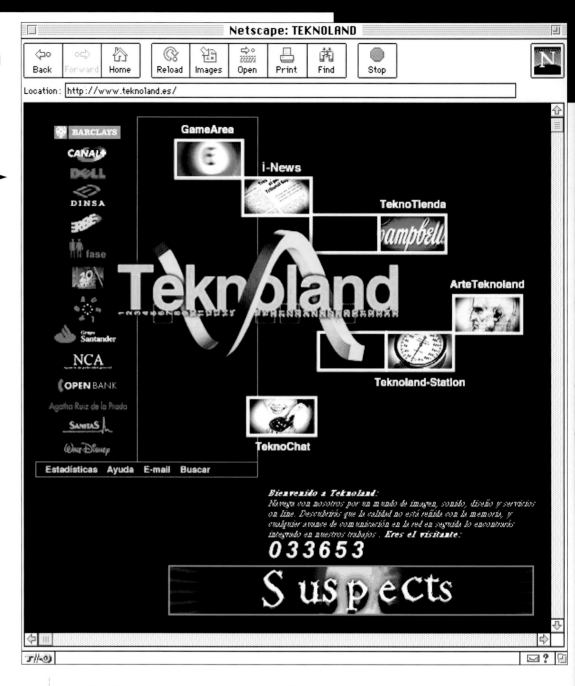

SELF-PROMOTION

The Teknoland site showcases the artistic and technical design and programming skills of the Spanish design firm Teknoland. The home page allows access to numerous areas, such as game and chat areas, and contains links to Teknoland's clients.

The site displays a high degree of technical expertise, implementing chat rooms, online gaming, and Shockwave streaming audio for an online radio station.

Its "Suspects" game features 95 actors and over 2,500 images. Viewers get to play the game via a Myst-like interface. Although the site is predominantly Spanish, the designers anticipate an English version of "Suspects" to increase accessibility.

The finished look of the site is accomplished by the use of dark backgrounds, clean lines, and sharp imagery. The Teknoland spiral logo used as a header element unifies the site.

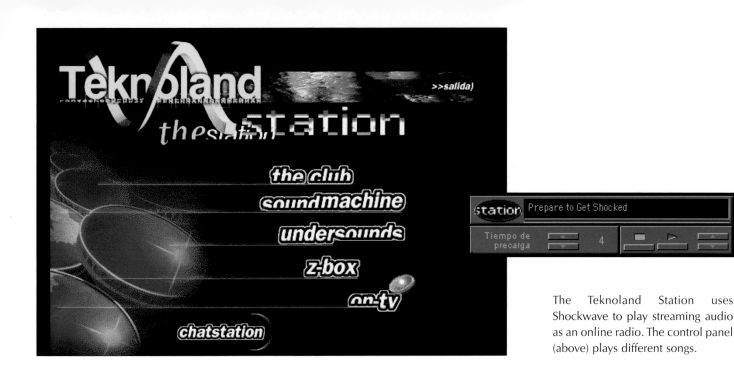

The Teknoland Station uses Shockwave to play streaming audio as an online radio. The control panel (above) plays different songs.

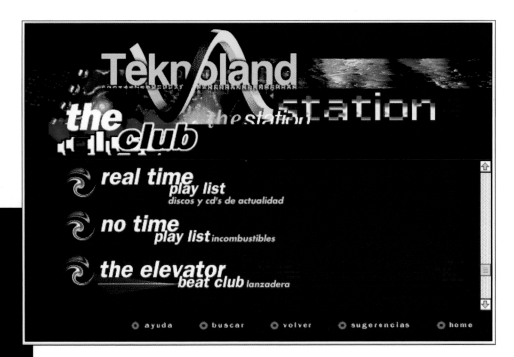

Project: Teknoland

Design firm: Teknoland

Art director: David L. Cantolla

Programmers: Colman Lopez,
Jesus Suarez, Rafael Sarmiento,
Cesar M. Ibanez

Features: GIF89a animation,
Shockwave, streaming audio

URL: http://www.teknoland.es/arte/fura/

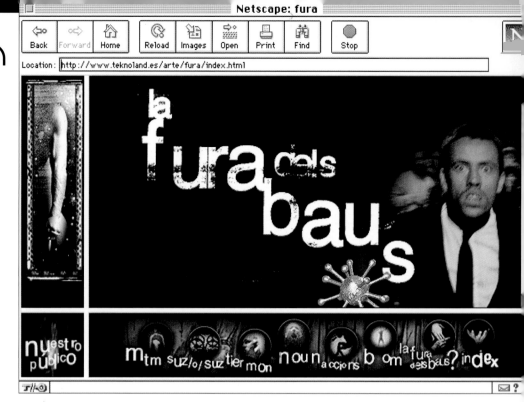

Netscape: fura

Location: http://www.teknoland.es/arte/fura/index.html

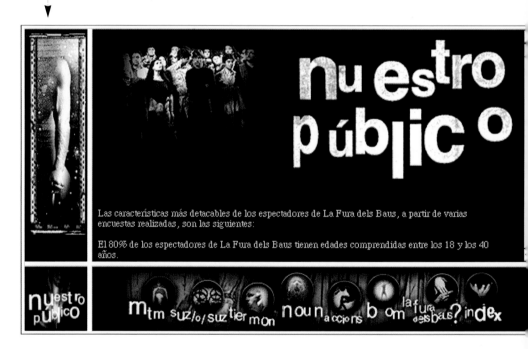

ENTERTAINMENT

La Fura dels Baus is an innovative Spanish performance company whose artistry was featured at the 1992 Olympic Games in Barcelona. The monolingual Spanish Website, created by Teknoland as an offshoot of the design firm's self-promotional Website, uses frames to divide the screen into four areas: a scrolling main center screen, two linking areas ("Nuestro Público" and the lower menu bar), and one vertical image display area.

This Website relies on computer-enhanced photographic images, rather than illustrations, enhancing the dramatic realism of the theatrical group's work. Gritty text, roughened frames, and dark backgrounds add to this effect—the black background is more a stage than a background, which incidentally improves the download time of the entire site.

The vertical image frame at the left of the browser window is an image chooser. Images selected here appear full-size in the large window. These images have been artistically manipulated and show a great sense of controlled mystery, as shown in the vertical image bars to the right.

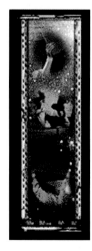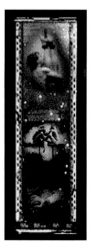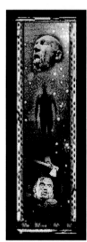

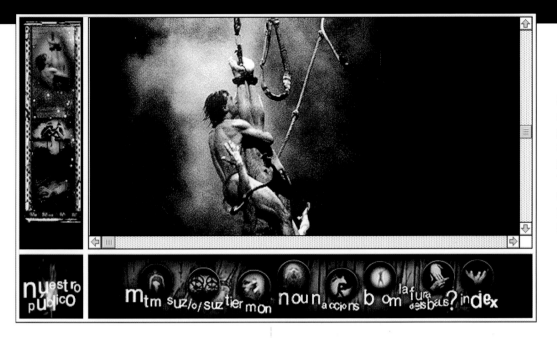

Scrolling text is placed in the main window over a black background. The image to the top left uses a wide monotone photographic image very effectively. The type is still readable over it, and the use of a limited color palette helps the site download more quickly.

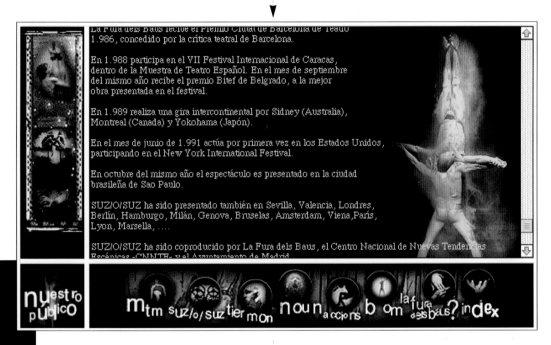

Project: Teknoland

Design firm: Teknoland

Art director: David L. Cantolla

Designer: Jose Luis Garcia

Programmers: Colman Lopez, Jesus Suarez

Authoring: Nestor Matas, Michael Mangicotti

GIF89a animations: Jose Luis Garcia, Michael Mangicotti

Features: GIF89a animation, Java scripting, Shockwave, streaming audio

URL: http://www.cameralink.se

SELF-PROMOTION

Camera Link AB is a resource for anyone in need of high-quality photography.

The site's "About Us" information lists the Link team as consisting of "nine photographers and eight stylists, all respected as leading talents in their fields." After browsing through the images shown on the site, it would be hard to disagree.

Robot, the design firm that created the Camera Link, had to keep in mind that viewers would want to access a huge gallery of images. To accommodate this, they created search engines that make the images easy to find.

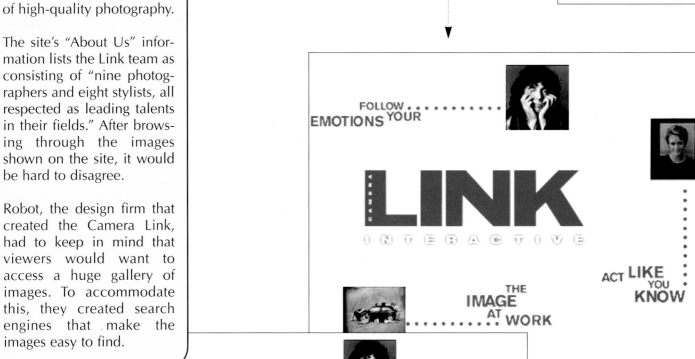

The splash page to Camera Link AB opens with the company logo as a GIF89a animation. The "N" in the word Link rotates into place and pauses until the user clicks and continues to the contents screen.

IMAGES AT WORK

Examples of: Still Life

SHOW ME!

CONTACTS ABOUT US
EMOTIONS WORK PEOPLE

WHERE DO YOU WANT TO GO?

Looking for feelings like: Exotic

Captured in: Portrait

SHOW ME!

There are two design elements implemented in the Camera Link site that stand out even among the artists' amazing photos. The first is the search engine that allows viewers to find specific images. Pop-up menus allow users to search for images with "Feelings" such as "Exotic," and "Captured in" styles such as "Portrait." Choosing different feelings and categories returns different images. The second element is the use of a Java rollover that presents the viewer with a navigation bar any time the mouse cursor moves over the "Link" logo, allowing the viewer to move easily from one area of the site to another.

EMOTIONS BY LINK

Looking for feelings like: Adventure

Captured in: Documentary

SHOW ME!

CONTACTS ABOUT US
EMOTIONS WORK PEOPLE

WHERE DO YOU WANT TO GO?

Looking for feelings like: Adventure

Captured in: Documentary

SHOW ME!

Project: Camera Link AB

Client: Camera Link

Design firm: Robot

Designer: Raket/Robot

Programmer: Jesper Weissglas

Features: GIF89a animation, Java scripting

URL: http://www.hasselblad.se

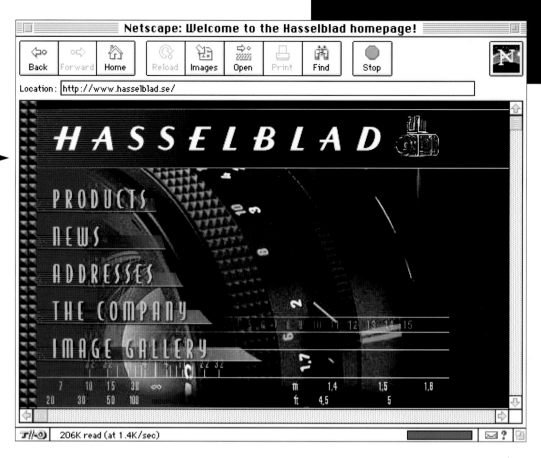

Netscape: Welcome to the Hasselblad homepage!

Location: http://www.hasselblad.se/

206K read (at 1.4K/sec)

COMMERCIAL

Long regarded as the premier manufacturer of cameras and photographic equipment, the Swedish company Hasselblad continues this tradition by bringing high-quality design to its Website.

Based on a camera lens, the home page graphic sets the style and navigation structure for the rest of the site. Focal distance, f-stop, and aperture settings add to the overall camera feeling, allowing viewers to relate easily to the navigation and contents.

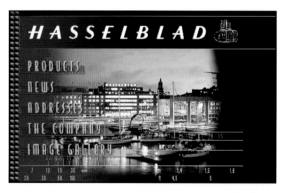

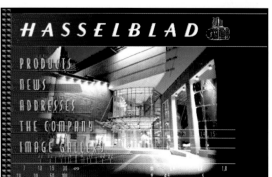

Visitors to the Hasselblad page will notice that the main image of the camera body loads in several different pieces: header, background image, and navigation bar. This allows the designers to switch the main graphic with the three photographic images shown at left, and also to cache images that will be used throughout the site, such as the "Hasselblad" header at the top of each page.

A blue, black, and gray color palette on all of the main images gives a professional photographic look to the site, while the orange and white type contrasts nicely and makes for easy viewing and quick recognition of navigation elements.

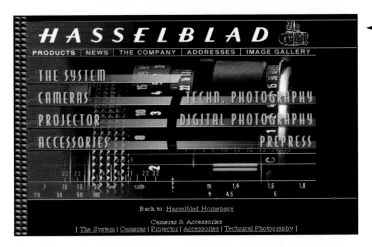

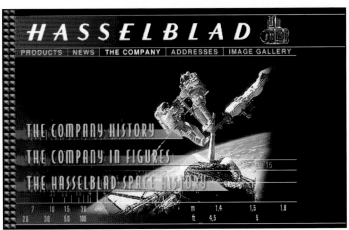

Project: Hasselblad

Client: Victor Hasselblad AB

Design firm: AdEra Digital Media AB

Designers: Jaanus Heeringson, Ola Carlberg

Illustrators: Jaanus Heeringson, Laszlo Nagy

Programmers: Jaanus Heeringson, Ola Carlberg, Thomas Friberg

Photographers: Jens Karlsson, Victor Hasselblad AB

Netscape: IGUANA: Welcome to a long lasting relationship

Location: http://www.algonet.se/~renvall/torget/motell/index.html

MAGAZINE

Iguana describes itself as a pop-culture magazine, using the metaphor of a motel to showcase the various areas of the site.

The designers created the site with the idea of '50s advertising in mind, offering the viewer the clichéd "100% satisfaction" guarantee that the media used during that era.

The magazine's graphical aim was to create the illusion of a three-dimensional interface, making it seem as if the illustrations were coming out of the pages rather than sitting flat on the pages.

The *Iguana* home page offers viewers a Swedish–English language graphic resembling the roof of a '50s motel, which links to the "Reception Desk" (shown below). Rather than develop separate Swedish and English Websites, the designers have incorporated English articles and Swedish text within the site, and they have used English navigation bars throughout.

entrance reception guests regulars lounge elevator

media and comfort culture authority

art

art node
Swedish contemporary art.

graphics content update
4 4 1

Colorful navigation bars are used in the site, but not consistently. In the bottom image, the header shows viewers that they are in the "Guests" area. Using headers in this way throughout would help viewers to find where they are in the site and to recognize where they have been.

Skip the text, I want to adopt now.

IN 1974 A GROUP of Hare Krishna believers bought a small piece of land somewhere in the North American countryside and settled there. They named their new home "Gita Nagari", the village where the Bhagavad-Gita is both practiced and sung.

The object of their lives was now to reveal and to show the natural beauty of the close relationship between earth, the animals, humanity and their God, Krishna. The work and life of the village became a kind of message about a society

guests

Horatius. Intervju med filosofen som gick från tanke till handling på X2000. Favorit i repris.

 o l d

Greg Araki Ung regissör från New York.

"Give us your e-mailaddress and we'll give a free subscription back."

Project: *Iguana*

Client: *Iguana* magazine

Design firm: Mats Renvall Produktion

Designer: Mats Renvall

Photographers: Mikael Hols, Erik Regnstrom, Mats Renvall

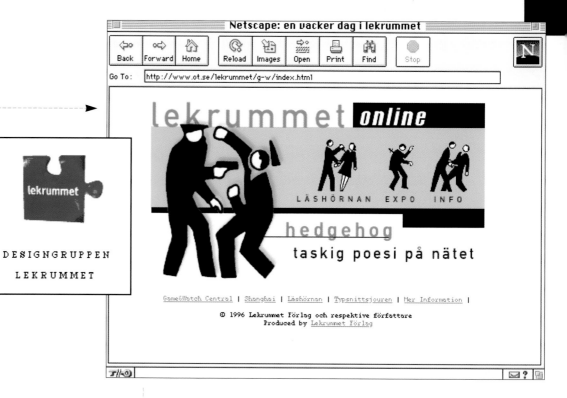

DESIGNGRUPPEN
LEKRUMMET

Lekrummet Online is a Swedish design firm's tongue-in-cheek presentation of its portfolio and design philosophy.

Humorous silhouette illustrations of people being robbed, stabbed, and beaten are used as icons to represent various areas of the portfolio.

If viewers can pull themselves away from the murder and mayhem, what they will see is a high-quality promotional piece showing the designer's light, humorous, and creative sides.

One of the most outrageous elements of the design is an area that, when entered, displays a "Fatal Error" dialog box that will instantly set any viewer's heart racing as they momentarily think their computers have bombed.

Using a basic color palette of only green and black sets the site up as a low-bandwidth download. The opening splash page features a GIF89a animation, a rotating puzzle piece that spins until the user clicks to enter the site.

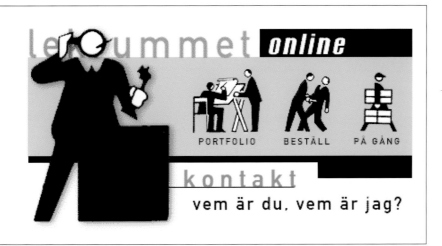

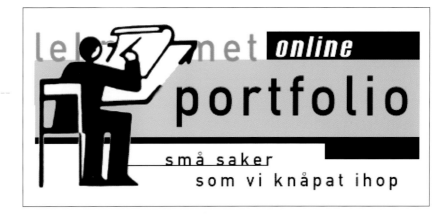

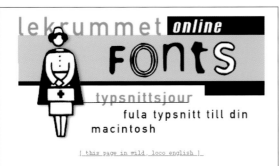

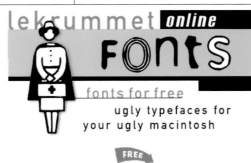

The bilingual "Online Fonts" area features five or six free downloadable fonts designed by the firm. Offering free resources such as this is an excellent way of attracting viewers to the site.

Project: Lekrummet Portfolio

Design firm: Lekrummet Design

Designer: Jörgen Jörälv

Programmers: Jörgen Jörälv, Alex Picha

Photographers: Mikael Wehner, Jens Petersen

Features: GIF89a animation, downloadable files

URL: http://www.raket.se

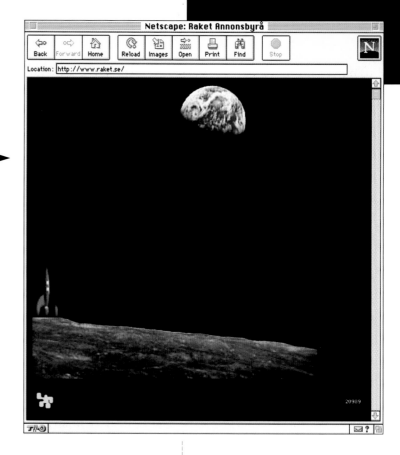

```
Netscape: Raket Annonsbyrå
Back  Forward  Home  Reload  Images  Open  Print  Find  Stop
Location: http://www.raket.se/
```

SELF-PROMOTION

The Raket Website, created by the Robot design firm, uses a beautiful, Myst-like ambient interface.

An interactive GIF89a image-mapped animation of a rocket landing on the moon with a bright sun behind the landing strut replaces the traditional navigation bar or text/icon-based image map. After the rocket lands, a door opens and an astronaut floats out. Viewers can click on either the open door or the astronaut to move to the inside of the rocket, becoming immersed in the site's unique environment.

This site represents an innovative step forward in Website organization—where the traditional home page is replaced by an experience.

Raket features a beautifully rendered moonscape and bright red rocket glinting in starlight. The interior of the rocket is similarly rendered in touchable detail.

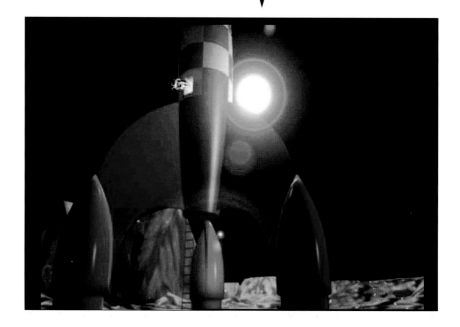

The sophisticated use of links and image mapping gives viewers the effect of changing perspective as they navigate through the interior. In the top image the viewer goes up the ladder, indicated by the light flowing through the hatch. In the middle image, viewers are drawn to the brightly lit control panel, which, when clicked, turns into the navigation panel for the site (below).

Project: Raket Portfolio

Design firm: Robot

Designer: Raket/Robot

Illustrator: Jesper Weissglas

Programmer: Jesper Weissglas

Features: GIF89a animation

ASSOCIATION

The Hub is a U.K.–based multimedia design association that maintains The Hub Website in addition to holding monthly member meetings to discuss the creative uses of desktop computers.

Viewers can link to several areas from the colorful home page. The logo link in the center takes visitors to an area where samples of creative work by The Hub members, including multimedia projects, can be searched for and downloaded.

The site serves as a resource for The Hub members, with info on local meetings and links to member home pages, but it is also of interest to visitors, with a "Computer Tips" area and articles of interest to designers.

The corrugated metal background of the home page (above) is reused as a vertical bar in the directory (below). The repetition of this texture lends continuity to the site.

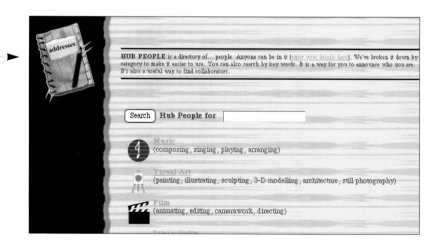

HUB HAPPENING is our noticeboard. You will also find information on our local Hub meetings.

LOCAL HUBS

HUB FEATURES brings you in-depth information, articles and projects that provide insight into what you can create with your computer.

 Writing
(literature, script-writing, poetry)

 Sound
(recording, mixing, dubbing, sampling)

HUB HYPER HOMES are the home pages of Hub members, actually on The Hub itself. If you'd like to have Home of your own, then mail us and we'll let you know. HyperHomeowners have full FTP access to their own are of the server, and where appropriate use of some of our scripts and CGI applications. These Homes are limited in number, though, so they will be allocated on a first-come, first-served basis. If you are unsure about how to write HTML, you can download my "Guide to HTML", in Adobe Acrobat PDF format. The Acrobat reader is available from HubTools.

HUB HELP is here to help you to learn how to get the most out of your computer. You know a good link and it isn't here? - let us know

HUB TUB positively encourages you to *copy that floppy*. Download your floppies, discuss them with friends, vote on them and then make your own. The only rules for posting material to this site is that it will fit onto a floppy disk and that it is legal. If you have work that you would like to post to The Hub Tub email us in the firs instance so that we can work out the best transfer method.

You can find more floppies in Hub Heaven.

A variety of backgrounds and textures is a strength of this site—in particular, note the nicely executed transitions in each of the above images from the texture at the left to the texture at the right. Also note the creative icons in the left column. These appear first on the home page—their repetition here reinforces the continuity of the site.

Project: The Hub

Design firm: The Hub

Designer: In-house

Features: downloadable files

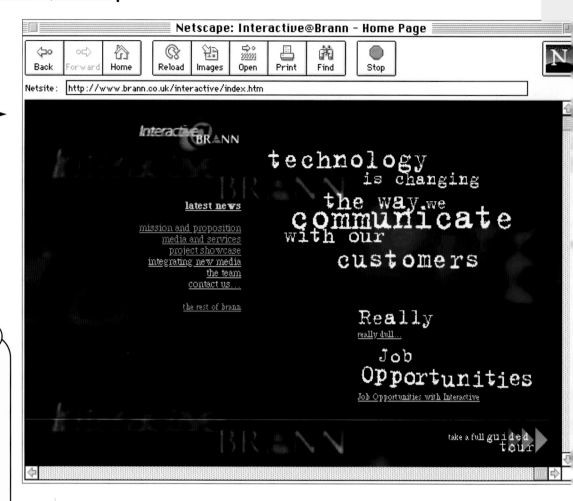

Netscape: Interactive@Brann – Home Page

Netsite: http://www.brann.co.uk/interactive/index.htm

Interactive@Brann is the multimedia arm of its parent company, Brann. Its mission statement reads that the company seeks to "deliver compelling creative solutions" for clients in all forms of interactive media.

If the design of this site is any indication, Interactive@ Brann is staying true to its mission.

The site opens with a stylishly blurred background that loads quickly, followed by an overlay of layered contemporary type that gives the site a cutting-edge typographical look.

Though the background comprises dark burgundy and black, the designers skillfully present all of the text for easy reading and recognition.

The designers overcame the problem of using boring-looking HTML text on the site by using bright RGB colors for active links and visited links. To maintain the continuity of the color palette, the same bright color scheme appears in all of the graphics and icons throughout the site.

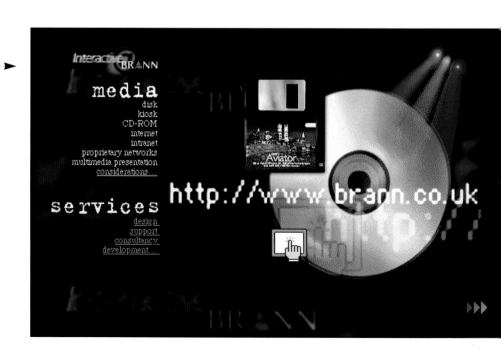

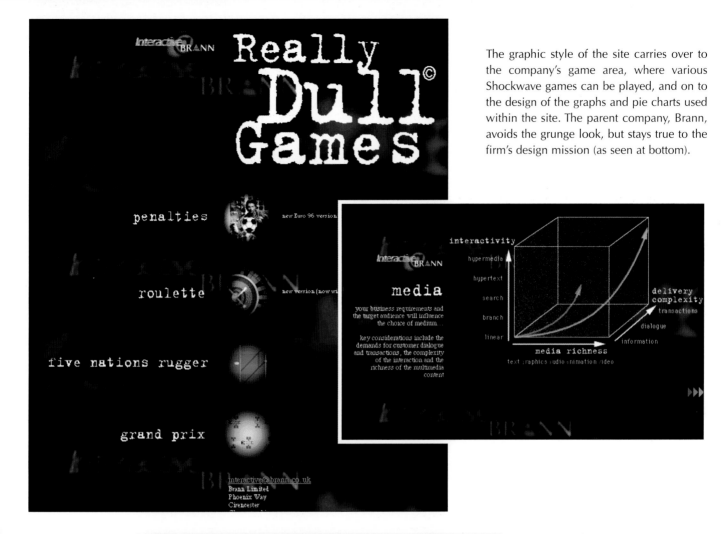

The graphic style of the site carries over to the company's game area, where various Shockwave games can be played, and on to the design of the graphs and pie charts used within the site. The parent company, Brann, avoids the grunge look, but stays true to the firm's design mission (as seen at bottom).

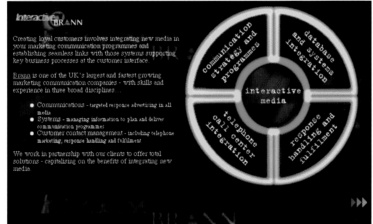

Project: Interactive@Brann

Design firm: Interactive@Brann

Designer: Chris Dawson

Illustrator: Theo Louca

Programmer: Richard Hookway

Photographer: Tony Dünn

Features: Shockwave animation

MAGAZINE

Pulpit is a design magazine about different kinds of design, from fashion to graphics to gardens. To quote Ruairidh Lappin, the Website's designer, "Everything is designed. Badly or otherwise."

Pulpit is well designed, featuring excellent typography and dynamic use of color to unify the Website.

The splash page of the Website (above) features a rotating 3-D GIF89a animation of the *Pulpit* logo. To its credit, the magazine prides itself on its literary content as well as design, giving viewers a choice between a text-only version or a text-and-image version.

Instead of using conventional HTML text, which allows no control over leading or spacing, the designer of *Pulpit* opted to use images of text on a white background.

The blue-and-gold title and author treatment (left) add continuity to the site by creating a visual motif signifying "article."

The middle image is an exhibit of photographs exploring the open palm as a personal message. It is an example of appropriate and sensitive use of frames to display a photographic exhibit.

"Pocket Fiction"

Photographs by David Moore for the Lincolnshire Photography Commission.

"The series, 'Pocket Fiction' finds us looking at open palms, a gesture for greeting, ordinarily reserved for people we know or who we meet for the first time.

In David Moore's photographs, we meet, for the first time, strangers, people who like us were asked to represent themselves through their choice of object presented to his lens. The stark and disconnected images we see isolate these choices for us to

Pulpit checks out the bars, restaurants, hotels which feed all the senses. Here, Oliver Bennett investigates wagamama Ñ the new-look noodle bar.

Project: *Pulpit*

Design firm: Ruairidh Lappin Associates

Designer: Ruairidh Lappin

Programmer: Ruairidh Lappin

Editorial team: Ruairidh Lappin, Lucia Wildon, Susan Ward Davies

Features: GIF89a animation

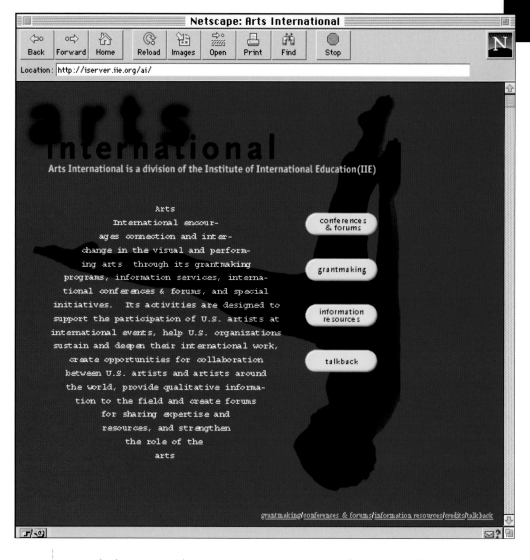

Netscape: Arts International

Location: http://iserver.iie.org/ai/

EDUCATIONAL

Arts International is a world-wide resource for the visual and performing arts community to facilitate collaboration on an international level.

The home page incorporates dynamic, contemporary typography with photography to convey the feeling of movement and dance. This treatment is used throughout the site, complemented by bright, colored backgrounds and buttons that keep file sizes to a minimum.

The designers worked to keep the site clean and easily navigable by offering a limited number of links on each page and by keeping text to a minimum wherever it is used.

The home page (above) uses a text treatment not often seen outside of print design. The circular text block catches the viewer's attention, aided by the directional lines of the dancer's legs, which draw the eye to the copy.

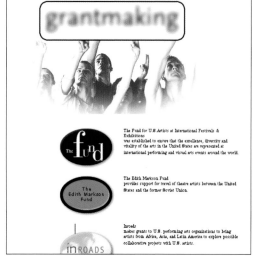

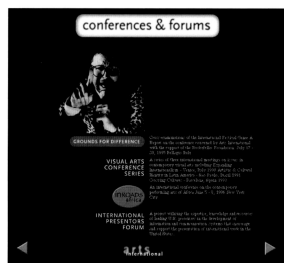

Navigation arrows for forward and backward movement are used within specific areas of the Website, taking the place of a traditional navigation bar or hypertext links.

A basic color palette allows quick download of each page. Keeping to these palettes allows the designers to incorporate graphics where bitmapped HTML text might normally appear, such as the three black oval titles at left.

Another trick to keeping image files small is demonstrated on the images below and to the right, where the designers use colorized photos—switching them from full-color to single-color images.

Project: Arts International

Design firm: Oven Digital

Designer: Rebecca Lown

URL: http://www.att.com/college

The large "College Network" logo on the home page features a GIF89a animation that cycles through the words "Connect," "Communicate," and "Get Ahead."

COMMERCIAL

The AT&T College Network is an excellent example of branding geared to a specific market on the Web. The site promotes the AT&T brand name to college students within a fun, helpful, and cutting-edge design, while staying away from the "hard sell" that many companies use to promote themselves.

The designers at Modem Media used carefully optimized animated GIFs and Shockwave within the site to add action and movement to each page.

The site offers visitors a large quantity of information resources, games, and access to free products, as well as special discounts and offers on AT&T services and products.

Playing off the "Network" title of the site, the designers have created a television-like interface with which viewers can easily identify, while including animated buttons such as the bottom "control dial" on the navigation bar to help carry the theme.

Two main GIF images were used throughout the site: the static image-mapped navigation bar (to the left), and the changing main feature image to the right of the bar.

Using a white background also helps to conserve download time.

Project: AT&T College Network

Client: AT&T CSB

Design firm: Modem Media

Designers: Lino Ribolla,
 Aurea DeSouza

Copywriters: Tom Beeby,
 Gordon Miller

Producer: Gregg Leonard

Features: Shockwave animation,
 GIF89a animation

URL: http://www.olympic.att.com

Netscape: AT&T 1996 Olympic Games Site

Netsite: http://www.olympic.att.com/

COMMERCIAL

The AT&T Olympics site is a creatively designed site, but is also an amazing work of production and organization. The site, created specifically for the 1996 Atlanta Olympics by Modem Media, included an on-site live hourly feed, athlete home pages, and a switchboard designed for people around the world to communicate during the Games.

At the height of Olympic excitement, the site's traffic reached two million hits in a single day and averaged one and a half million hits daily during the remainder of the Games.

In order to handle this volume of traffic, the firm acquired the use of three high-volume Web servers.

To compete with all of the Olympic sites that were operating during the 1996 Olympic Games, Modem Media needed to create a site that would be memorable and have elements that couldn't be found in other sites. One of the most fascinating is the "Olympic Museum Tour." Here viewers are able to stroll through a museum of Olympic history and download QuickTime VR movies (such as the Carl Lewis shoe shown below, which can be rotated 360°).

The AT&T Online Games
presented by
AT&T WorldNet Service

The AT&T
Olympic Games Connection

AT&T

HURDLES

Wait

"SPACE BAR": ACTION KEY "J": DECREASE SPEED "K": INCREASE SPEED

At the starting gun (or, if you don't have sound, the green light), hit the space bar to start. Watch the speed meter to check your pace. Higher speeds gain higher scores, but speed makes hurdling harder. If you nick the hurdle, you'll stumble, lose time, and look very uncool.

SCOREBOARD

AT&T Global
Olympic Village
Live

AT&T Olympic
Games
Switchboard

Olympic
Museum Tour

Athlete
Home Pages

The AT&T
Online Games

The AT&T
Centennial
Olympic Games
Send-off

To The AT&T
Olympic
Home Page

Among the fun elements the Modem Media team designed into the site are the four "AT&T Online Games," which can be played in real time on a 28.8 baud modem. Viewers are offered the chance to compete in the Olympics through Shockwave "Hurdles," "Pole Vaulting," "Diving," or "Basketball." Scores from these games are kept in a current scoreboard that can be accessed at any time.

Speed

The AT&T Online Games
presented by
AT&T WorldNet Service

The AT&T
Olympic Games Connection

AT&T

12.0

You'll have to master these five steps to get a great score in the Pole Vault: Plant, Compress, Jump, Handspring, and Release. The green light indicates the best time to perform each of these maneuvers. Here's how the game works:

Press the space bar to begin running, again to make your pole plant, again to compress for your vault, again to make your jump, again to handspring upward, and once more to release.

For a higher vault and a better score, press K to speed up your running approach. If you're afraid of heights, press J to slow your run down to a skip. (Chicken!)

Plant 3 Speed ▪ ● ● ● ○

"SPACE BAR": ACTION KEY "J": SLOWER "K": FASTER SPEED

SCOREBOARD

AT&T Global
Olympic Village
Live

AT&T Olympic
Games
Switchboard

Olympic
Museum Tour

Athlete
Home Pages

The AT&T
Online Games

The AT&T
Centennial
Olympic Games
Send-off

To The AT&T
Olympic
Home Page

Project: AT&T Olympic Games

Design firm: Modem Media

Creative Dir.: Joe McCambley

Assoc. Creative Dir.: David J. Link

Art Directors: Tracy Long, Stefanie Trinkl

Producers: Joseph Salvati, Glen White, Bob Carelli

Features: Shockwave animation, GIF89a animation

We are proud to introduce the 26 U.S. athletes sponsored by the AT&T Olympian Network. This sponsorship provides financial assistance and AT&T products and services to help these outstanding performers keep in touch with family and friends while they train. If you already have the Shockwave plug-in and would like to see the Shockwave version of these pages, click the "Shock Me" button below. If you need the Shockwave Plug-in, you can get it here.

◆ **SWIMMING**
Summer Sanders
Jenny Thompson
Mel Stewart
Jeff Rouse
Janet Evans

◆ **DIVING**
Mary Ellen Clark

◆ **GYMNASTICS**
Bill Roth
John Roethlisberger
Scott Keswick
Dominique Moceanu
Trent Dimas
Dominique Dawes
Shannon Miller

◆ **SOCCER**
Mia Hamm

◆ **TRACK & FIELD**
Gail Devers

◆ **BASKETBALL**
Teresa Edwards

◆ **KAYAKING**
Dana Chladek

◆ **BEACH VOLLEYBALL**

◆ **VOLLEYBALL**
Kim Oden

◆ **CYCLING**
Rebecca Twigg
Connie Paraskevin-Young
Marty Nothstein
Steve Hegg

◆ **WATER POLO**
Alex

AT&T Global
Olympic Village
Live

AT&T Olympic
Games
Switchboard

Olympic
Museum Tour

Athlete
Home Pages

The AT&T
Online Games

The AT&T
Centennial
Olympic Games
Send-off

To The AT&T
Olympic
Home Page

To The AT&T
Home Page

URL: http://atlas.organic.com

ENTERTAINMENT

@tlas is an online magazine featuring photography, multimedia, design, and illustration. The premiere issue (shown here) was designed as a portfolio piece for the companies involved in its creation. Subsequent issues were more editorial and less like a portfolio.

Each issue of *@tlas* has a distinctive look characterized by unique borders around hyperlinked photos; blurred, angled, and layered text; and diffused glows that highlight buttons and images.

Visitors to *@tlas* include professional designers looking for resources that will help them in their field, as well as visitors who are looking for interesting content displayed in a contemporary design.

The *@tlas* magazine home page sets the tone for this contemporary Web magazine. Rules are used to draw the user's eye to the TV-like contents windows that are used on each issue's home page (above and below), while layered and staggered typography are used to define the navigation areas.

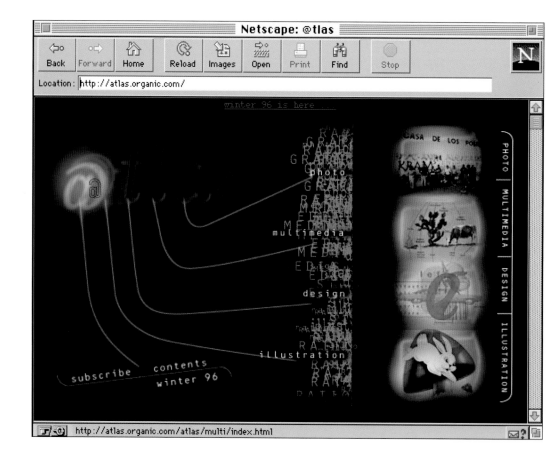

Directional radio waves draw the user's eye to the names of the three multimedia firms whose interactive work appears in @tlas. Layered behind the name are blurred yellow spotlights, breaking up a solid background.

Each issue of *@tlas* features a different editorial section such as the "Technicolor Gods" article (at left) which focuses on Indian iconology. The page uses related images, color, and typography to indicate a specific theme. The TV window (lower left corner) cycles through a GIF89a animated sequence of Indian gods to keep the page from becoming stagnant.

The large blurred arrow in the background (bottom) helps point users to three clickable navigation images and highlights the illustrator's images against the light yellow background. Feathered edges on the icons soften the page, contrasting with the hard rules and bitmapped text.

Project: *@tlas*

Design firm: *@tlas* Web Design

Creative director: Olivier Laude

Senior designer: Amy
Franceschini

Co-designer: Summer 1996:
David Karam

Programmer: Michael Macrone

Features: Shockwave animation,
RealAudio, downloadable files

URL: http://www.autodesk.com

The Autodesk Website features a conservative design-that enhances the professional aspect of the 3-D design software company's site.

To keep the site from becoming overly conservative and boring, the designers chose an energetic color scheme to liven up the pages. Feathered edges and shadowing on images and buttons soften the pages, making them more inviting.

To better profile its products, the banners on each main title page show images created with Autodesk's 3-D rendering products.

Not wanting to completely abandon a contemporary Website design, Autodesk had their slogan "Designing Your World" designed with a creative type treatment (above).

Clicking on a partial image (located at the top right of the home page, above) for Autodesk's "Support and Training" section takes the viewer to the main title page and displays a fully-rendered image on the banner above.

A banner that displays an image or design produced with one of the company's 3-D products heads each of the main pages throughout the site.

Project: Autodesk

Design firm: In-house

URL: http://www.bmge.com

Two images load on the home page: the large background image of the Bertelsmann building (BMG headquarters) and the image-mapped circular navigation strip that repeats on each main page. For faster navigation through the site, a hypertext-based navigation line is included at the bottom of each page.

COMMERCIAL

The BMG Entertainment Website created by Avalanche promotes the music company's labels, products, and entertainment services in North America and Europe.

One of the most striking element's of BMG Entertainment's Website is the use of the large GIF that loads in on the home page showing the company's corporate headquarters. Though the image is large enough to fill a browser window, it has been optimized for quick download by keeping to a basic palette, so it loads in quickly on a fast modem.

For continuity, the circular GIF image on the title page is used on each of the successive pages in the site. Once the viewer has reached secondary pages, such as the music labels, the page design changes to fit specific areas.

Once viewers enter the music labels area, they are able to choose from various sections promoting specific music genres.

The "Peeps Republic" section (left) focuses on BMG's jazz, R&B, and other labels.

Project: BMG Entertainment

Client: BMG

Design firm: Avalanche

URL: http://www.boxtop.com

Boxtop Interactive's home page is a beautiful piece of image-mapped art that grabs the viewer's attention from the moment it begins loading. The swirling spiral image is hypnotic, with its bright colors augmented by the spinning logo icon that continuously loops until the viewer clicks to enter another area of the site.

Boxtop's Web portfolio is divided into interactive and international design clients, each of which carries the dynamic spiral motif.

Boxtop created the international home page to promote an image as a global design company. The swirling artwork maintains continuity with the home page.

This long image (right) from the "Lab" area offers image-mapped navigation for browsing through Boxtop's Shockwave projects. It also shows a whimsical, lighter side of the company's design capabilities.

The opening page of Boxtop's Website gives visitors the opportunity to view a Shockwave promo of the company's portfolio. Clicking the Shockwave link loads a smaller animation (above) that loops until the final animation (inset above) loads. The final animation is a presentation that loops through portfolio images as it follows the cursor around the screen until the mouse is clicked.

Project: Boxtop Portfolio

Design firm: Boxtop Interactive

Designer: John Ng

Programmers: Jeff Koga, John "Fess" Fessenden, Jason Fiber

Features: GIF89a animation, Shockwave animation

URL: http://myth.com/color

Netsite: http://myth.com/color/

STRETCH YOUR SCREEN AT LEAST TO THE WIDTH OF THIS LINE OF TEXT

Color Therapy

Photography by Suza Scalora

This is a graphically intensive site and the images will take time to come up

click VIEW THIS SITE IN NETSCAPE 2.0 OR HIGHER

EDUCATIONAL

Color Therapy features the photography of Suza Scalora in a uniquely color-driven site. There are many ways to organize information and experience—this site uses color to organize images, rather than icons or text. The effect of color throughout the site is similar to that of stained glass, especially in the icons used to navigate to different sections of the site.

These photographs are optimized for 16-bit viewing rather than the standard 8-bit palette. This maintains the quality of the photos, while keeping the download time of the rest of the pages low, as they remain optimized at 8-bit.

green

The checkerboard color picker above loads one color chip at a time, until the board completely fills. This image has not completely loaded in all the color chips. Viewers can either select a color chip to go to a photograph or use an icon at the bottom of the page to visit other areas of the site.

color meditation · Color Therapy · zone out

Meditate on color. It is simply the art of opening your eyes. Just have a look. Relax your body. Expect nothing from yourself but to SEE.

Be aware of your mood. Select an emotion from the pull down list below. Click "zone out" and a color will appear for your 2 minute meditation. As you gaze into a color, draw the color into your body with your eyes. Allow the color to become you and feel a tuning within. At the completion of your 2 minute meditation a message will be displayed at the bottom of the page. It will prompt you to slide up a color bar. Two data entry boxes will be revealed. One for your email address, one for your emotions and feelings.

Collect your email and explore the power of color

The color meditation page to the left is actually an interactive experience. Viewers click on the "Zone Out" icon to start a two-minute meditation period gazing at a color they have chosen. At the end of two minutes viewers can record their feelings in an e-mail to themselves. Response to this portion of the site has been very positive.

Color Therapy · **photo gallery** · browse

Water painted crystal images dripping down a human form. A human life. Photographer Suza Scalora awakens the life force inherent in color. Worship the Sun Goddess bathed in indigo. Frolic with the Wood Nymph through the forest of green. Soar the skies with the aqua Aviator. "Browse" the gallery of characters.

help pick a color color meanings color meditation photo gallery

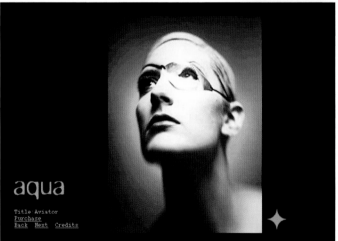

aqua

Title:Aviator
Purchase
Back Next Credits

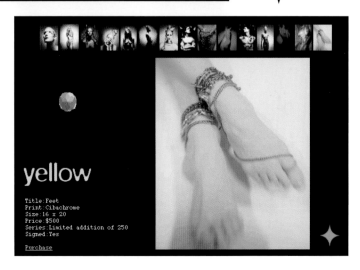

yellow

Title:Feet
Print:Cibachrome
Size:16 x 20
Price:$500
Series:Limited addition of 250
Signed:Yes

Purchase

Project: Color Therapy

Client: Suza Scalora

Design firm: Anderson Perrault Inc.

Designer: Carin Ullman

Programmer: Robert Reich

Photographer: Suza Scalora

Features: Java scripting

SELF-PROMOTION

An ethereal angel on a gently graduated color background greets visitors to Digital Planet's home page. Angels are used on all subsequent pages, with changes in their size and color drawing attention to various sections of each page. Layered and transparent typography evokes a contemporary feel—the underlying concept for the viewer is that of a guardian angel.

The designers also use Shockwave animation to generate an interactive content navigation tool, shown on the opposite page, demonstrating technological expertise without sacrificing artistic excellence.

In the image above, the small angel guides the viewer toward the main navigation bars located in the center of the page. The larger angel in the background points viewers toward the Shockwave section of the site. In the image below, the placement of the angels effectively draws the eye to the navigation bars in the center and the text at the bottom of the page.

The Shockwave sequence shown here (top to bottom) displays an animated contents sphere gliding into view to the strains of eerie background music. It disappears, then reappears with video screens embedded in its surface. Each video screen displays a looping animation that links to different areas of the site. As the image appears, blinking eyes in the dark background come into focus, surrounding the sphere.

Project: Digital Planet Portfolio

Designers: Michael Lenahan,
 Scott Ford

Programmers: Bill Rini,
 Tamara Coombs

Features: Shockwave animation

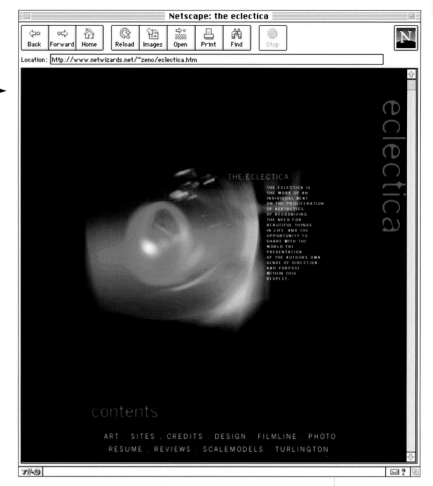

The Eclectica is the personal Website and portfolio of designer Jonathan Leong. The site is filled with luminescent computer-generated images created by the designer. Navigating this site is simple —an image-mapped menu bar at the bottom of the home page links to the designer's résumé, examples of his work, and a list of his favorite art and film links.

Thoughtful musings from the designer—laid out with typographical sensitivity using reversed type against a dark background—characterize the site. The Eclectica is more than an online portfolio—it is an expression of the designer's personal design philosophy.

Creative vertical typographic layouts on several pages use short line lengths to evoke a feeling of poetic free verse.

The "Film Line" section (left) of the site offers the designer's own collection of film reviews, discussion, and links.

Each page shows a beautifully rendered collage or computer-generated illustration with contemporary layered typographic treatments.

Project: The Eclectica

Design firm: Drawbridge

Productions

Designer: Jonathan Leong

URL: http://www.elektra.com

COMMERCIAL

The Elektra Entertainment Website, created by Avalanche, uses jagged, cutting-edge illustration to give the site the exciting, alternative look and feel of an album or CD cover. Each page features a unique image-mapped illustration that links to the company's artists, new releases, and other music-resources.

Avalanche used large, relatively slow-loading images throughout the site, and kept away from over-optimization that could degrade the graphic images. To balance this download problem, the designers chose to create a low-res alternative to the high-res version of the site. Visitors to the site can choose between the fast-loading version or the high-res version, which may take a little longer to download.

To make accessing the main area of the site easier, the designers placed a pull-down menu at the top of the page. This menu allows viewers to choose a specific artist and click the "Go" button to enter the artist's page. For viewers with slower modems, the designers placed the link to the low-res version at the very top of the page, making it the first accessible element to load.

click for directory

click to wander halls

Each main title page contains an original graphic that continues the look of the home page illustration and helps to keep continuity throughout the site. Secondary pages, such as the artist page below, use limited palettes and minimal graphics to help speed download.

Jump to lo-bandwidth version

what's new...

e Take a look at our **NEW RELEASES.**

e DO YOU WANT TO JOIN THE CURE ON TOUR? GET THEE TO :

TOWA TEI

SOUND & VIDEO CLIPS
DISCOGRAPHY

Ipanema was never like this.

Traveling on a Techno beam of swing, gliding over smooth brushstrokes of Caribbean salsa and Brazilian funk, clipping heels with hearty doses of brass horns and pummeling club beats, *Future Listening!* is a global wink and a nod -- to the grooves and movements of a fast-changing music world. But this time Towa Tei, the programming guru behind Deee-lite smashes *World Clique* and *Infinity Within,*

The blurred arrow helps point users to three clickable navigation images and highlights the illustrator's images against the light-yellow background (top). Feathered edges on the icons soften the page in contrast to the hard rules and bitmapped text.

Project: Elektra.com

Client: Elektra Entertainment Group

Design firm: Avalanche

Features: RealAudio, downloadable files

URL: http://www.eye-q.com

COMMERCIAL

Eye Q Records uses a navigation element that is growing in popularity with designers who wish to devote their pages solely to content. When viewers enter the Eye Q Records domain, a navigation palette opens at the right side of the main Web page. This contents palette can be moved off to the side, placed behind the main page, or resized to fit whatever space is available. When the viewer wants to access different areas of the Website, clicking on the palette brings it forward and makes it active.

The design of the Eye Q Website is clearly directed at a younger audience interested in rave culture and alternative music. Rough, organic textures mix with high-tech circuitry and psychedelic '60s-style colors and patterns.

The navigation palette (top and lower left) loads in only once, keeping viewers from having to wait as button icons or navigation GIFs reload each time they enter a new area.

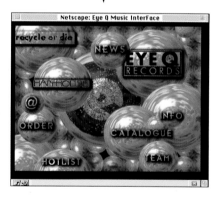

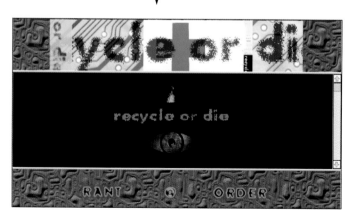

Small GIF89a animations, such as the spinning 3-D eye and fire (above), add motion and energy to the site.

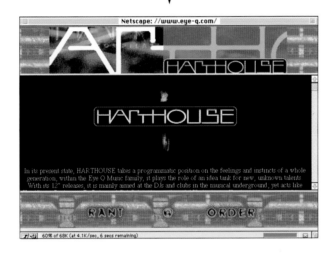

Some areas within the Eye Q Website use frames (bottom and middle images), others don't (top), depending on how the designers decide to present the information. Switching between these two types of layout adds variation to the site and helps to keep viewer interest.

Project: Eye Q Music

Client: Eye Q Music Inc.

Design firm: Interverse

Designers: John Mellon, Valerian Bennett, Bidiol

Programmers: John Mellon, Jeff Sherwood

Features: GIF89a animation

URL: http://www.iliad.com/gravicadesign/

Netscape: gravica design group

Location: http://www.iliad.com/gravicadesign/

215 Copley Road | Upper Darby, PA 19082 | Voice:610.734.1818

SELF-PROMOTION

The Gravica Website demonstrates an ability to incorporate rich photo collage, graphics, and typography while keeping download times reasonable with page file sizes under 40k.

The black background sharply contrasts with the colorful and luminescent images.

Because the designers dislike the way HTML text looks when used on a Web page, they decided to make the majority of their text bitmapped artwork, admitting that this wouldn't work well for some clients because it increases download time.

A GIF89a animation cycles through the company's motto: "Transcend the mind with captivating design." The same luminescent typography is used on sub-pages to indicate active areas.

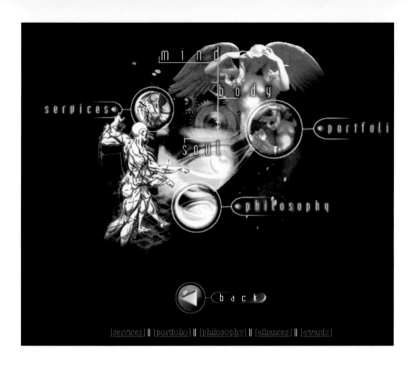

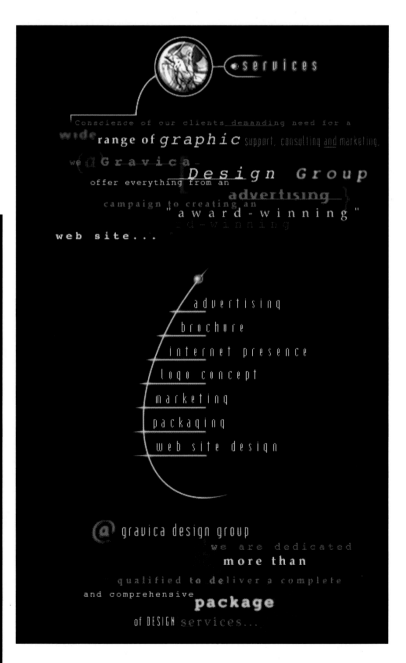

The planetary orbital ellipse from the home page is repeated as a navigation element, replacing the more commonly used rectangular navigation bars.

Project: Gravica Portfolio

Design firm: Gravica Design Group

Designers: Michael McDonald, Charles Molloy

Programmers: Michael McDonald, Seth I. Rich

Netscape: Homicide: The Case

Back Forward Home Reload Images Open Print Find Stop

Netsite: http://www.nbc.com/homicide/case.html

ENTERTAINMENT

The "Homicide: Life on the Street" Website, based on a popular U.S. police television drama, is characterized by a dark, seamy look, as though the site had been dusted for fingerprints, an effect accented by the dark background used throughout the site.

A distressed typewriter font is used in an image-mapped GIF for navigating the different stages of an investigation, from "the body" to "the box" (a.k.a. interrogation room), and finally to "the end." Viewers are given an experience separate but similar to the sequence of an episode of the show.

A site such as this can develop a larger following for the show among new viewers, as well as deepen the attachment current viewers have for the program. It also allows for some tracking of visitor demographics by the broadcasting network.

Edges, borders, and clean lines are not respected in this site. Note the overlap between GIF and text in the lower part of the page below, as well as the intrusion of the horizontal lines of the background onto the edges of both images. The effect unsettles the viewer and blurs visual meanings in the same way that clues at a murder scene are not always easily interpreted.

You walk around the edges of the scene looking for spent bullets, casings, blood droplets. You get a uniform to canvass the houses or businesses nearby, or if you want it done right you go door to door yourself.

You examine the body and its immediate surroundings for loose hairs or fibers on the off

Murder investigation photos are collaged and used as a subtle background for the section head for "The Cut," which features one actor's insight into the show. Ragged borders and irregular shapes are used to cue the viewer to click on image-mapped hot spots on the page (right and bottom). The effect is one of incompleteness and uneasiness.

Kyle Secor on Detective Tim Bayliss

Do you hang out with cops?

The first year, we were taken to various **criMe-sCene** locations, and a lot of cops would show up on the set, and we had time to talk to them. We followed the **Adena Watson** case for six episodes that year, and the officer that originally took that case is the officer my character was based on. He wanted to be there the night that we **find the**

body.

They decided that he would be the **fiRst** officer on the scene. It happened to be **raining** that night, and he stayed with the actress that played the dead girl all night long - **keeping her warm**, keeping her dry. And my

Project: "Homicide: Life on the Street"

Design firms: NBC Multimedia Inc., Avalanche Systems Inc.

Designers: Stephen Jablonsky (NBC), Andreas Lindstrom (Avalanche)

Programmers: Stephen Jablonski (NBC), Elisha Sessions, Robin Schuldenfrei (Avalanche)

Features: GIF89a animation

URL: http://www.eden.com/~dhopkins

EDUCATIONAL

Duncan Hopkins's portfolio Website is characterized by its hand-to-eye coordination—the splash page of the site is dominated by a grayscale eye that fades in and changes to a blue tint with a simple moving type treatment.

A contents page replaces the splash screen—the designer's own hand, accented by an animated GIF89a eye that slowly gazes to the left and right, makes up the interface. Section titles linking to e-mail, haunts, a gallery, and a portfolio radiate from each finger, fading in and out. All the pages have a simple white background and lightly colored type.

This interface shows a nice mix of photographic elements, illustration, Japanese katakana (which translates to the designer's name), and rules to guide the eye.

Hopkins's skill at creating traditional and computer-generated illustration are clearly shown in the image-mapped "Gallery" page, above left, and the frames version of the "Monstrosium," below.

Project: Duncan Hopkins
Portfolio

Design firm: Syndetic Design

Designer: Duncan Hopkins

Features: GIF89a animation

When Web designers use large graphics, the wait for the image to download can be painfully long. The designers at Indulgent Arts solved the waiting problem by first loading a grayscale image of the home page graphic. Viewers can then either wait for the color image or enter the magazine directly.

ENTERTAINMENT

Indulgent Arts is an online magazine exploring the myriad issues of sexuality. The magazine offers viewers articles, fiction, and erotica, as well as up-to-date information about health, AIDS, and safer sex in a private, non-threatening environment.

The magazine's philosophy states: "Our lifestyles reflect the public and private expression of who we are." This Website reflects the expression of its designers and displays what is often a controversial subject in a beautifully designed and illustrated format.

Elegant typography and photomontages placed against a white background give the magazine a clean, professional, yet inviting look.

The contemporary type treatment in the circular icon used on the contents page and on the navigation bar at the bottom of each page contributes to the stylistic continuity of the site.

Welcome to Volume III of Indulgent Arts!

Each of the main title pages includes a photomontaged banner containing imagery relating to the content of the specific page. The designers use a limited palette for each image that allows each page to download more quickly.

Project: *Indulgent Arts*

Design firm: C.A.P.

Designer: Rhonda Anton

Illustrator: Rhonda Anton

Programmer: Craig Bramscher

Photographer: Craig Bramscher

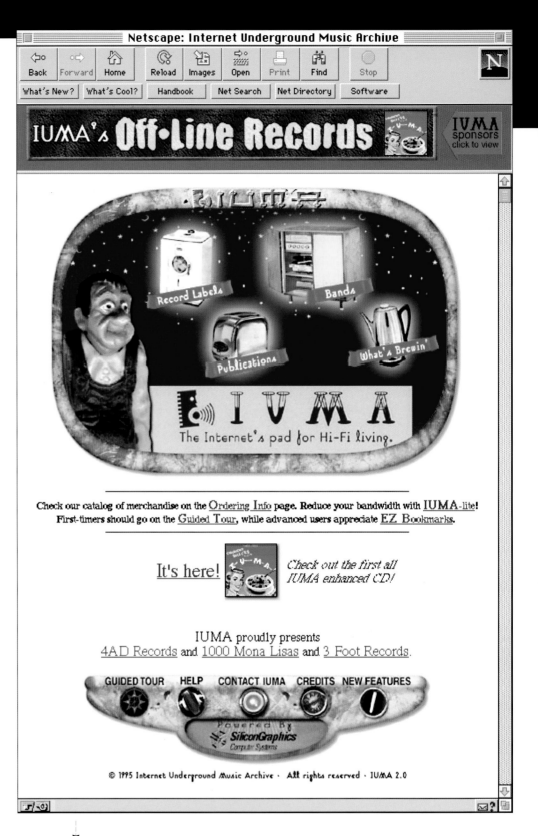

ENTERTAINMENT

The creators of the IUMA (Internet Underground Music Archive) Website had one mission in mind when they first conceived of their Website: create the Internet's first free high-fidelity music archive. Their mission was a success. IUMA houses more than 500 independent artists and labels, as well as major labels such as Warner Bros. and Geffen Records.

The site's "Publications" section lists a large selection of traditional and online e-zines working with IUMA.

IUMA's designers combine their expertise in using up-to-date Web technology (for presenting live video and audio concerts) with their ability to create some of the most imaginative and beautifully rendered navigation bars on the Web.

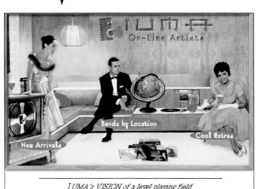

The IUMA home page allows new visitors to take a guided tour of the site, or dive right in and start exploring by using highly creative navigation bars and image-mapped graphics.

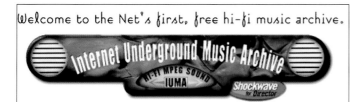

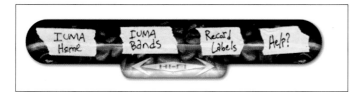

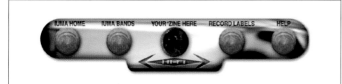

One hallmark of the IUMA site is its artistically rendered button bars. Each page features a stylistically distinct bar for navigating through the site.

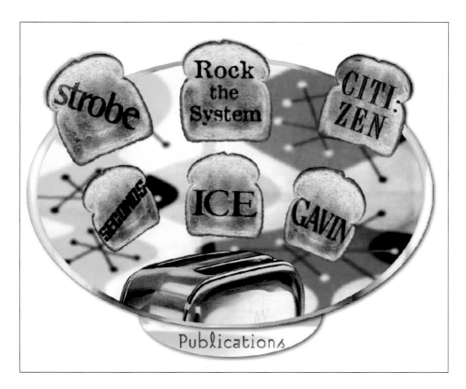

IUMA hosts a number of e-zines and online publications at its site. This graphic above breaks away from using traditional button bars, instead using an image-mapped graphic that is fun and unique enough to catch the viewer's attention.

Project: IUMA (Internet Underground Music Archive)
Design firm: In-house
Designers: Brandee Selck, David Beach
Programmer: Jeff Patterson
Features: Shockwave animation, RealAudio, downloadable files

URL: http://www.razorfish.com/bluedot/greenberg

Netscape: Jill Greenberg: The Manipulator

Location: http://www.razorfish.com/bluedot/greenberg/

SELF-PROMOTION

Photographer Jill "The Man-ipulator" Greenberg's Web-site links to Bluedot, an online arts site published by Razorfish Design. The Green-berg site resembles an off-beat detective game, with its "Rap Sheet," "Mug Shots," and "Eyewitness" reports. These unfold to reveal Greenberg's portfolio and list of clients.

This site succeeds in enticing visitors to linger and investi-gate the "Exhibits." From the very first page there is a fun, quirky energy in the design and concept that engages viewers. The "Eyewitness" section is actually a bulletin board where visitors can leave comments. A brief sam-pling turned up a variety of sincere and humorous re-marks. The detective theme also enables the use of a number of strong images, such as revolvers, handcuffs, and badges, as icons.

The designers chose to use GIF89a animations sparingly throughout the site. Only one animated icon loops on the home page to draw the viewer's attention to "Exhibit 5," an area where QuickTime movies can be downloaded. Each of the "Exhibit" icons leads to a main title page where viewers can browse through the photographer's portfolio.

Image-mapped navigation graphics continue the theme of the site for each of the main portfolio pages. Clicking on a badge, set of handcuffs, or chambered bullets takes the viewer to a larger image, and clicking on the animated GIF bullet that shoots across the page takes the viewer to the next section. To make navigating the site easier, thumbnails of the photographer's works are provided in the "Mug Shots" section (below left).

Project: Jill "The Manipulator" Greenberg

Design firm: Razorfish

Designers: Craig Kanarick, Stephen Turbek, Juliet Martin, Thomas Müller

Photographer: Jill Greenberg

Programmer: Ot Lubling

Features: GIF89a animation, RealAudio, QuickTime, downloadable files

137

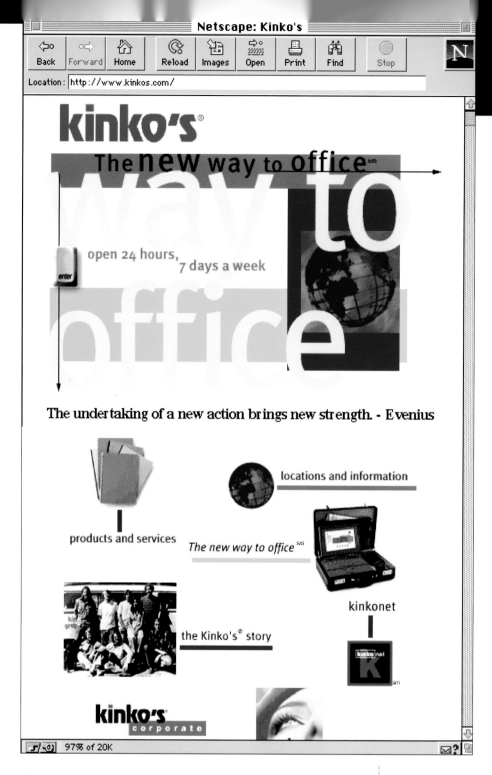

Netscape: Kinko's
Back Forward Home Reload Images Open Print Find Stop
Location: http://www.kinkos.com/

COMMERCIAL

The Kinko's Website represents the international diversity of the growing copy center chain. Significantly, the Kinko's home page is available in eleven different languages in addition to English, including Hebrew and Vietnamese.

The Website maintains the "Kinko's look" that includes a basic color palette and a distinctly conservative, yet clean and visually appealing design. The use of white backgrounds and chunky blocks of dynamic colors are characteristic of the company's print materials; these elements work well for Web design, and also serve—incidentally—to keep download time short.

The home page (above) features an animated GIF globe that cycles through multiple color palettes and a notable quote that periodically changes. A header icon (below) is used consistently on each page, with captions and colors changing to fit the various sections.

Dutch

The Kinko's home page was translated and designed to accommodate twelve different languages, including Japanese, Korean, Dutch, Russian, Hebrew, Arabic, German, Chinese, French, Spanish, Vietnamese, and English.

Spanish

Hebrew

Korean

Project: Kinko's

Client: Kinko's

Design firm: Hal Riney &
 Partners/Heartland Inc.

Team leaders: Chris Kimm,
 Mary E. Hamilton (Kinko's)

Programmer: Organic Online

Features: GIF89a animation

URL: http://ww.ak.com

Welcome to KnightNet

Location: http://www.ak.com/index.html

Document: Done.

COMMERCIAL

The KnightNet Website represents the global recruitment and employee communications agency Austin Knight to corporate clients seeking its services and to job-seekers looking for placement. Its message must be communicated quickly on a visual level in a way that impresses both audiences. The business-oriented site uses contemporary typography, a clean, easily accessible interface design, and a cool color palette of blues and grays.

Visitors can enter the site and rapidly collect information about the company. The areas of the site featuring its creative output, as in the design of corporate print recruiting campaigns, are themselves examples of creative problem solving. The site demonstrates that what it does for itself, it can do for a client.

The blue and grey palette that the designers chose for the site's main color theme give the pages a professional, business-like feel, while the icons and navigation bars show a more contemporary side of the company's creative department.

The navigation bar above carries the theme of the home page throughout the site and works well with other images that have been optimized to the same basic color scheme. It is also reminiscent of a knight's lance, playing off the company's name.

Section heads such as the one shown below for "Creative of-the-Month" break away from the concept of using small headlines and icons for intro headings. Though the image is large, it has been optimized for downloading and loads quickly on a 28.8 baud modem.

The Problem: LSI LOGIC designed and implemented an innovative, effective rotational program for new-graduate hires who wished to transition into technically astute sales and marketing professionals. This mentoring program provided needed skill sets, confidence and deep-product knowledge necessary to really know how LSI LOGIC and

Project: KnightNet

Design firm: Austin Knight Inc.

Designer: Martin Kraus

Programmers: Ben Klau, Gary Zellerbach

URL: http://www.leejeans.com

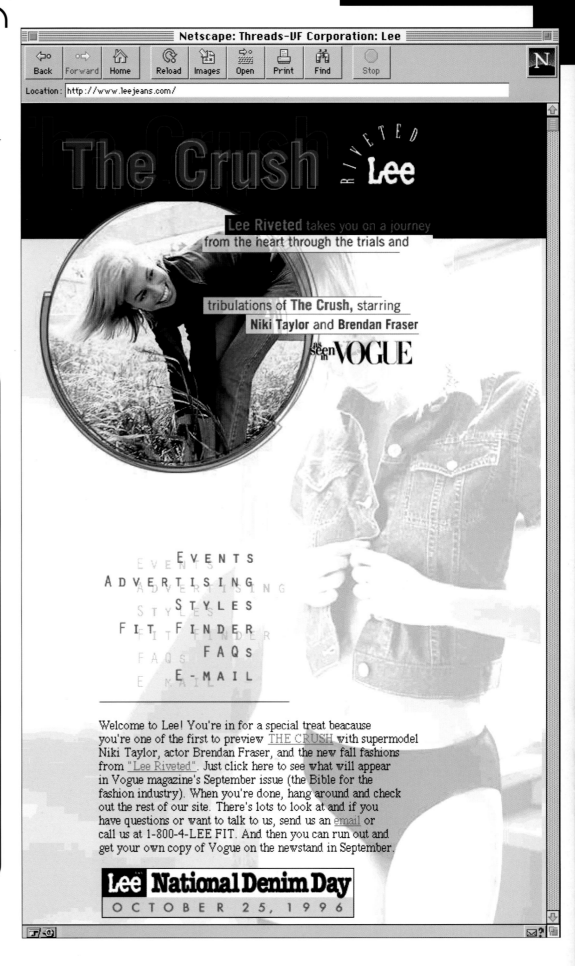

COMMERCIAL

As with other sites by Avalanche, the Lee Jeans Website incorporates a large background image that takes a while to download, but is worth the wait. High-quality design and interesting typography greet visitors, along with images of supermodel Niki Taylor wearing Lee Jeans apparel.

In conjunction with *Vogue* magazine, the designers created a promotional campaign for "The Crush," a series of billboard-type advertisements with a story featured in print in *Vogue*.

The site effectively uses large photos screened back and used as background GIFs on different pages. The optimization process adds graininess to the images, creating very soft images that load relatively quickly for their apparent size.

She looked like **something** out of an Ingmar **Bergman** film, with a **Cadillac** walk and skin too creamy to be believed.

As seen in VOGUE

NEXT:

Easy does it. [HOME PAGE.] The Boy Cut blasted jean, about $38 and the textured V-necked knit, in all-purpose black, about $26. By Lee Riveted.

Lounging around. [THIS PAGE.] White Satin shine shirt, about $34, worn with Easy Fit, blue-black sandblasted jeans, about $38. Both by Lee Riveted. 1-800-4-LEE-FIT

RIVETED Lee

Where can I buy your jeans?
Call 1-800-4-LEE-FIT for information on where to find the store closest to you.

How much shrinkage should I expect after washing my jeans?
3/8" to 1" in the inseam. The waist won't shrink. It may seem a bit smaller after you wash it but it will stretch after you put them on.

Do you have catalogs?
We don't currently produce a catalog, but please call us for information about any products you are interested in.

Are Lee jeans made in the U.S?
80% of our jeans are manufactured here in America. We employ over 10,000 workers in the U.S.

Can I exchange my jeans for another pair?
We will replace or repair any manufacturers defect. Just return the garment to the store of purchase.

HOW To take CARE of your Lee 100% cotton denim jeans.

DON'T FORGET TO READ
Read the product care label. Different products may require different care.

MOLLY WILEY LARA PATRICK MAX HOME

the Lee **fitFINDER**

Bras, swimsuits and jeans. They are the three items that most frequently frustrate female shoppers and force women into the fitting room blues. Now, thanks to the Fit Finder women have an easier time finding jeans that fit.

The Fit Finder, an interactive multim... a fun, convenient solution to jeans sh... shopping assistant, the fit Finder wor... jeans that match her size, personal tas... analyzing her input and matching pre... of colors, fits and finishes. Best of al... the product. The fit Finder is progran...

Been here before? If so, click on the latest episode, if not, start at n...

If you would like to be emailed when the next episode launches cli...

He's gone. (I mean Owen the magician.) Vanished. I have no idea...

QuickTime videos of Lee Jeans's most popular commercials are available for viewers to download (above left). High-quality typography, design, and photography are used throughout the Website (left). Another story-like promotional element of the site are the six characters whose lives are followed in short, serialized episodes (bottom).

QuickTime videos of Lee Jeans's most popular commercials are available to viewers for download (above). High-quality typography, design and photography are used throughout the Web site (right). Another story-like promotional element of the site are the six characters whose lives are followed in short, serialized episodes (bottom).

Project: Lee Jeans

Design firm: Avalanche

Features: downloadable QuickTime files

URL: http://www.luckman.com

Luckman Interactive, Inc. publishes several different software products designed for connecting to the Web and creating Web servers, as well as a *World Wide Web Yellow Pages* directory. The company's Website, designed in-house, is a beautifully designed forum to promote these products.

When images with multiple colors (such as a full-color photograph) are displayed on the Web, optimization of the graphics can become a problem—too much optimizing and the graphics begin to pixellate, too little and the image size is too large for downloading. The Luckman home page uses a two-color palette designed for easier optimization of the images. This palette is used for each of the header icons and maintains continuity throughout the site.

The home page, as well as additional pages throughout the site, features a visually appealing header surrounded by white space, which directs the viewer's attention to the image-mapped and hypertext-based navigation areas.

Instead of using flat scanned artwork of the company's packaging, the designers created 3-D images of the box for each individual software product and added depth and interest by allowing the graphics to float on the page.

Creatively designed 3-D icons are the focus of each title page. Using a gold palette for each icon allows the designers to easily match them with any other primary color.

Project: Luckman Interactive Inc.

Design firm: In-house

Creative director: Joe Spencer

Designer: Eric Yang

Illustrators: Eric Yang, Joe Spencer

Writer: Christopher Smith

Programmers: Richard Ford, Peter Benjamin, Joseph Fiero, Christopher Smith

URL: http://www.nissanmotors.com/pathfinder/

The home page opens with a Shockwave animation of the Nissan logo, which morphs into the main navigation map below. "Explorers" of this site may visit three destinations: Kenya, Tanzania, and Botswana.

COMMERCIAL

Many sites currently use Shockwave animation; few sites use it generously as the Nissan Motors "Pathfinder Safari." Shockwave animations are used on nearly every page of this promotional site.

To guide visitors through the site, the designers offer links to the tools needed to fully view the site.

For your trip through the site they've "replaced your tetanus shots and malaria pills with software applications," including QuickTime, QuickTime VR, and Shockwave.

To enhance the virtual experience of being on safari in Africa, the designers use earth tones throughout and offer maps that convey a feeling of exploration.

WELCOME TO BOTSWANA

Welcome to Botswana. Click on the various landmarks to tour the Botswana countryside. You'll witness beautiful scenery and mingle with the local Batswana. You'll even meet some wild, exotic and dangerous animals. We hope not for lunch.

A Shockwave navigation map allows viewers to select various destinations in each of the main areas. Clicking on a destination moves the Pathfinder vehicle across the page (at left and below), offering viewers choices that take them to either downloadable QuickTime videos or to more Shockwave animations.

You have met up with the warthogs. Click the Pathfinder to check them out or anywhere else to continue on you journey.

WARTHOGS

Perhaps in response to being given the name "warthog," warthogs like to dig enormous holes right in the middle of the road. But, as you've probably realized by now, whether you're on safari or on your way to pick up the kids after school, the Pathfinder® has ways of making the

WARTHOGS

Perhaps in response to being given the name "warthog," warthogs like to dig enormous holes right in the middle of the road. But, as you've probably realized by now, whether you're on safari or on your way to pick up the kids after school, the Pathfinder® has ways of making the

WARTHOGS

Perhaps in response to being given the name "warthog," warthogs like to dig enormous holes right in the middle of the road. But, as you've probably realized by now, whether you're on safari or on your way to pick up the kids after school, the Pathfinder® has ways of making the

While on safari in Botswana, viewers have the opportunity to experience humorous and engaging elements that have been designed into the Website, such as the Shockwave animation of warthogs (above), or the "Protective Coats" area (right) where viewers can see how various animal coats would look on a Nissan Pathfinder.

PROTECTIVE COATS

PROTECTIVE COATS

Project: Nissan Pathfinder Safari Adventure

Client: Nissan Motors Corp., USA

Design firm: TBWA Chiat/Day

Art director: Jeff Roll

Copywriter: Doug Schumacker

Illustrator: Leon Ng (Jamison/Gold)

Programmers: Brent Phillips, Jeff Ellermeyer (Jamison/Gold)

Features: Shockwave, QuickTime, QuickTime VR

ENTERTAINMENT

The *Papermag* Website is a digital companion to a paper-based alternative music and culture magazine of the same name. Over 50 neon-like icons and headlines unify the large site by creating a consistent and comfortable motif. The designers specified a black background to heighten the glow effect of the neon palette. The icons convey strong visual messages of adult fun and nightlife in addition to text-based information.

Simple animation treatments of some of the icons bring a spot of movement to each page—a four-stage GIF animation of a flickering match (opposite page) and a simple animation of a steaming cup of coffee grace the main pages of different sections—adding interest without becoming tiresome when revisiting the page.

The animated GIF89a animation "match" on *Papermag's* home page (above and opposite right) cycles through four GIF images, simulating a working neon sign, and continues looping until the viewer clicks on one of the navigation icons.

Many hours of image manipulation went into creating neon headlines for each of *Papermag*'s main pages, as well as the more than fifty icons that were created to simulate neon signs.

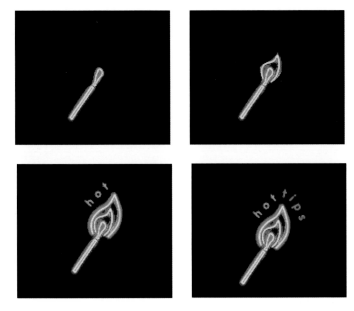

The sequence of GIF images above shows the progression of the animated match used on the home page to simulate a working neon sign.

Project: *Papermag*

Client: Paper Multimedia Inc.

Design firm: Socio X

Designers: Bridget De Socio, Mayra Morrison

Programmer: Avalanche

Features: GIF89a animation, RealAudio, downloadable files

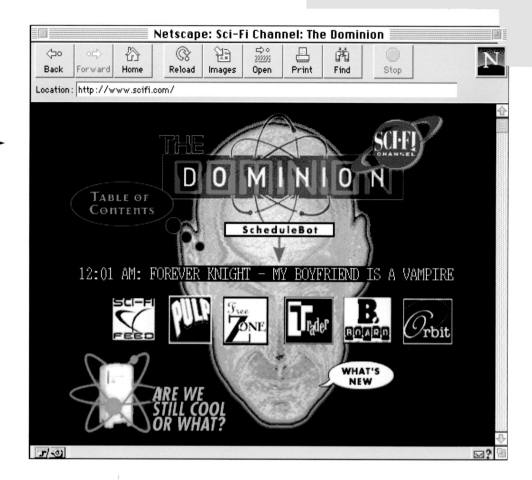

COMMERCIAL

The Dominion Website is a promotional vehicle for the Sci-Fi Channel, created specifically to attract and engage an audience interested in science fiction.

The site offers viewers from the United States, Europe, and Latin America a place to connect with each other, while also offering them a wealth of information, products, and science fiction resources.

The glowing green head of an alien greets visitors to the home page and immediately sets the tone for the rest of the site. Each page is highlighted by fluorescent colors and space imagery, along with layered text and buttons connected by rules, which form a high-tech, contemporary design for each area of the site.

The main graphic on The Dominion home page is broken into two main GIFs and is separated by the "ScheduleBot," a Java-scripted moving banner that gives viewers an up-to-date schedule of the channel's TV listings.

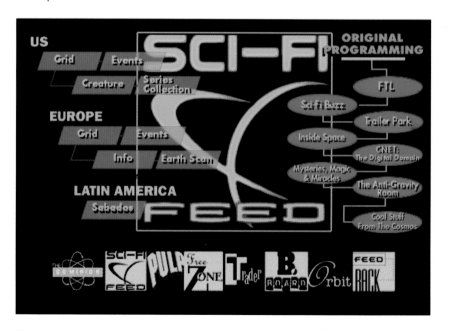

The designers have stayed away from using hypertext links for navigation, instead incorporating an icon-based navigation bar at the bottom of each page to give viewers access to all areas of the site.

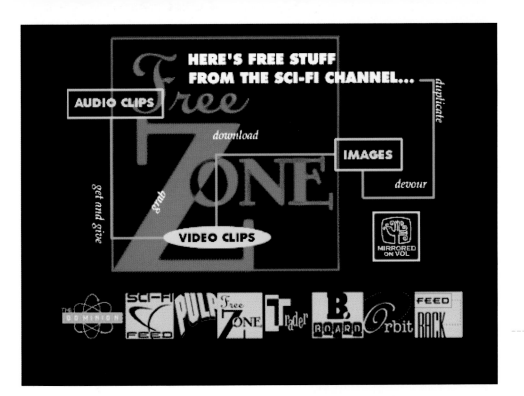

The limited palette of blues, reds, and greens against the black background keeps download times to a minimum. Rather than animated GIFs, which often slow a site down by delaying the loading of other GIFs, the designers have used bright neon colors to attract viewers' attention.

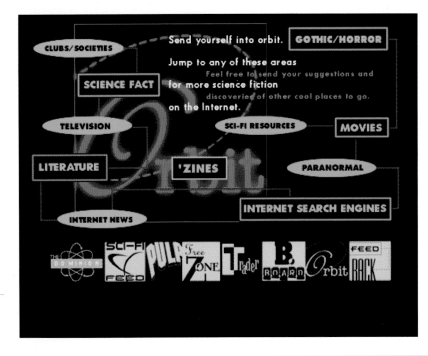

Project: The Dominion

Client: Sci-Fi Channel

Design firm: In-house

Designers: Gary Jamie,
Sean Micah, Troy Tracy,
Carlos, Hillary, Rachel,
Santiago, Sharleen

Features: Java scripting

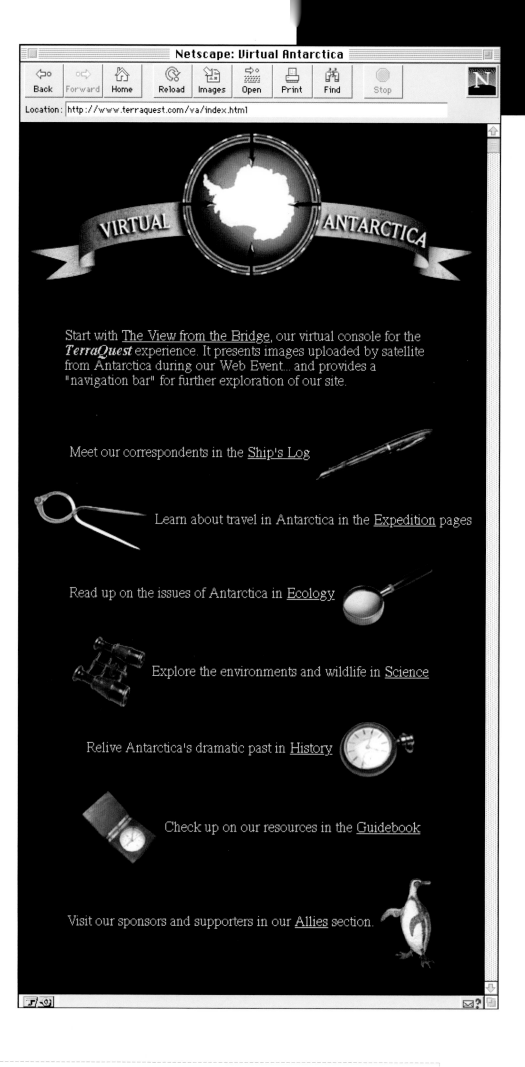

VIRTUAL ANTARCTICA

Start with The View from the Bridge, our virtual console for the *TerraQuest* experience. It presents images uploaded by satellite from Antarctica during our Web Event... and provides a "navigation bar" for further exploration of our site.

Meet our correspondents in the Ship's Log

Learn about travel in Antarctica in the Expedition pages

Read up on the issues of Antarctica in Ecology

Explore the environments and wildlife in Science

Relive Antarctica's dramatic past in History

Check up on our resources in the Guidebook

Visit our sponsors and supporters in our Allies section.

ENTERTAINMENT

TerraQuest was designed to bring interactive travel expeditions to the World Wide Web using the most current and dynamic technologies available.

TerraQuest's maiden voyage in 1996 was to the continent of Antarctica. With twice-daily live chats and digital dispatches linking thousands of viewers via Inmarsat satellite systems, TerraQuest made history by becoming the first commercial travel expedition to make live uplinks to the Internet from Antarctica.

Beautifully rendered imagery and a clean, easily navigable design have already garnered several awards for this engaging site.

"The View from the Bridge" is a virtual console for the TerraQuest experience. It presented images uploaded by satellite from Antarctica during the Web event and provided a navigation bar for further exploration of the site.

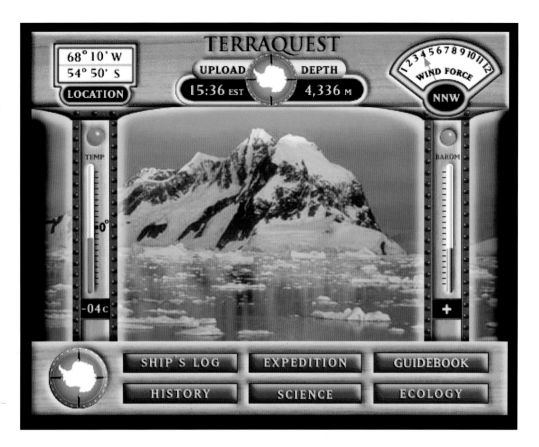

Project: Virtual Antarctica

Client: Mountain Travel•Sobek
and World Travel Partners

Designer: Brad Johnson

Principal photographer:
Jonathan Chester

Features: Shockwave animation,
RealAudio, downloadable files

Icons from the contents page (opposite page) representing the main areas of Virtual Antarctica were also used as headers, making each section quickly recognizable. Various map-like backgrounds and textures were used for each page, further adding to the feeling of exploration.

WWW DESIGN

WEB PAGES FROM AROUND THE WORLD

A

ACCESS TIME: Amount of time it takes a CD-ROM drive (or other type of device) to locate and retrieve information.

B

BANDWIDTH: Data transmission capacity, in bits, of a computer or cable system; the amount of information that can flow through a given point at any given time.

BANNER: A graphic image that announces the name or identity of a site (and often is spread across the width of the Web page) or is an advertising image.

BAUD RATE: Speed of a modem in bits per second.

BROWSER: A program that allows users to access information on the World Wide Web.

BUTTONS: Graphic images that, when clicked upon or rolled over, trigger an action.

BYTE: A single unit of data (such as a letter or color), composed of 8 bits.

C

CACHE: A small, fast area of memory where parts of the information in main, slower memory or disk can be copied. Information more likely to be read or changed is placed in the cache, where it can be accessed more quickly.

CD-ROM (Compact Disc-Read Only Memory): An optical data storage medium that contains digital information and is read by a laser. "Read Only" refers to the fact that the disc cannot be re-recorded, hence the term.

CGI (Common Gateway Interface): Enables a Website visitor to convey data to the host computer, either in forms, where the text is transferred, or as web maps, where mouse click coordinates are transferred.

CMYK: Cyan, magenta, yellow, black (kohl in German), the basic colors used in four-color printing.

COLOR DEPTH: The amount of data used to specify a color on an RGB color screen. Color depth can be 24-bit (millions of colors), 16-bit (thousands of colors), 8-bit (256 colors), or 1-bit (black and white). The lower the number the smaller the file size of the image and the more limited the color range.

COMPRESSION: Manipulating digital data to remove unnecessary or redundant information in order to store more data with less memory.

D

DPI: Dots-per-inch, referring to the number of halftone dots per inch or the number of exposing or analyzing elements being used. 72-dpi is the resolution of computer display monitors.

DIGITIZE: Convert information into digital form.

E

E-ZINE: A small self-published magazine distributed electronically through the internet or on floppy disk.

F

FPS: Frames per second.

FRAMES: Independently controllable sections on a Web page.

G

GIF: (Graphics Interchange Format) A file format for images developed by Unisys for CompuServe. A universal format, it is readable by both Macintosh and PC machines.

GIF89A ANIMATION: GIF format that offers the ability to create an animated image that can be played after transmitting to a viewer.

H

HOME PAGE: The Web document displayed when viewers first access a site.

HOTSPOTS: Areas onscreen that trigger an action when clicked upon or rolled over; usually these areas are not obvious to the user.

HTML: (HyperText Markup Language) The coding language used to make hypertext documents for use on the WWW.

HYPERLINK: Clickable or otherwise active text or objects that transport the user to another screen or Web page with related information.

HYPERTEXT: A method of displaying written information that allows a user to jump from topic to topic in a number of linear ways and thus easily follow or create cross-references between Web pages.

I

IMAGE MAP: A graphic image defined so that users can click on different areas of an image and link to different destinations.

INTERACTIVE: Refers to a system over which users have some control, which responds and changes in accordance with the user's actions.

INTERFACE: Connection between two things so they can work together; methods by which a user interacts with a computer

INTERNET: A global computer network linked by telecommunications protocols. Originally a government network, it now comprises millions of commercial and private users.

INTERNET SERVICE PROVIDER (ISP): Enables users to access the internet via local dial-up numbers.

INTRANET: A local computer network for private corporate communications.

J

JAVA: A programming language expressly designed for use in the distributed environment of the Internet.

JAVASCRIPT: An interpreted programming or scripting language from Netscape.

JPEG (Joint Photographic Expert Group): An image compression scheme that reduces the size of image files with slightly reduced image quality.

K

KILOBYTE: As a measure of computer processor or hard disk storage, a kilobyte is approximately a thousand bytes.

L

LINEAR: Refers to a story, song, or film that moves straight through from beginning to end.

M

MEGABYTE (MB): Approximately 1 million bytes.

MODEM: (modulator-demodulator) A device that allows computers to communicate to each other across telephone lines.

MORPHING: The smooth transformation of one image into another through the use of sophisticated programs.

MPEG: (Moving Pictures Expert Group) A video file compression standard for both PC and Macintosh formats.

MULTIMEDIA: The fusion of audio, video, graphics, and text in an interactive system.

N

NON-LINEAR: Refers to stories, songs, or films, the sections of which can be viewed or heard in varying order, or which can have various endings depending on what has preceded.

O

ONLINE SERVICE PROVIDER: An OSP is a company that provides access to the Internet through its own special user interface and proprietary services.

P

PALETTE DETERIORATION: Refers to the degradation of colors in the system color palette when graphics are over-optimized for Web implementation.

PALETTE FLASHING: When color pixels do not align correctly, such as in a GIF89a animation.

PLUG-INS: Plug-in applications are programs that can easily be installed and used as part of Web browsers.

R

REPURPOSE: To adapt content from one medium for use in another, i.e., revising printed material into a CD-ROM.

RESOLUTION: Measurement of image sharpness and clarity.

RGB (Red, Green, Blue): A type of display format used with computers. All colors displayed on a computer monitor are made up of red, green, and blue pixels.

ROLLOVER: The act of rolling the cursor over a given element on the screen, resulting in another element being displayed or a new action beginning.

S

SEARCH ENGINE: A software program that allows a user to search databases by entering in keywords.

SHOCKWAVE: The Macromedia add-on that allows users to create compressed Web animations from Director files.

SITE: A WWW location consisting of interlinked pages devoted to a specific topic.

SPLASH PAGE: An opening page used to present general information for the viewer, such as plug-ins or browser requirements.

STREAMING AUDIO: Sound that is played as it loads into the browser.

STREAMING VIDEO: Video that plays as it loads into a browser window.

T

T1 AND T3: High-speed digital channels often used to connect Internet Service Providers. A T1 runs at 1.544 megabits per second. A T3 line runs at 44.736 megabits per second.

THROUGHPUT: The rate of data transmission at a given point, related to bandwidth.

TRANSFER RATE: The rate at which a CD-ROM drive can transfer information.

TRANSPARENT GIF: A GIF image with a color that has been made to disappear into or blend into the background of a Web page.

U

URL: (Universal Resource Locator) Standard method of identifying users or machines on the Internet. May be either alphanumeric or numeric.

V

VIDEO CONFERENCING: Using online video to connect with one or more people for communicating over long distances.

VIRTUAL REALITY: A simulation of the real world or an imaginary alternative presented on the computer.

VRML: (VIRTUAL REALITY MARKUP LANGUAGE) The coding language used to create simulated 3-D environments online.

W

WWW: (World Wide Web) graphical Internet interface capable of supporting graphics within text, sound, animation and movies, as well as hypertext linking from site to site.

Check out these Website URLs for additional Web terminology:

http://whatis.com/

http://iasw.com/glossary.html

Australia
Q-Multimedia
10 Eastland St.
Dianella Perth. WA 6059
61.9.322.2977
E-mail: koyus@qmm.com.au

Austria
BRODYnewmedia
63 Lerchenfelderstrasse
Vienna, Austria A-1070
43 1 5264303
E-mail:
brody@newmedia.co.at

Belgium
PING
Interleuvenlaan 5
3001 Leuven
32.70.233.772
E-mail: frank@ping.be

Canada
Inform Interactive, Inc.
495 King St. West, Ste. 100
Toronto, Ontario
M5V 1K4
416.595.5232
E-mail: shy@informinterac-
tive.com

Mco Digital Productions
2226 York Avenue, Ste. 3
Vancouver, British Columbia
V6K 1C6
604.739.5803
E-mail: ph@mindlink.bc.ca

Media Renaissance, Inc.
1435 Rue de Bleury, Ste. 805
Montréal, Québec H3A 2H7
514.844.8866
E-mail:
benthin@montreal.com

Denmark
The Planet
Frederiks Allé 112B
DK-8000 Aarhus C
45.8618.0699
E-mail: rasmus@planet.dk

Space Invaders
Nyhavn 31 F
DK-1051 Copenhagen K
45.3311.5033
E-mail:
space@mail.invaders.dk

Finland
Henri Loikkanen
Kyyhkysmaki 3A 3
FIN-02600 Espoo
358.9.517.974
E-mail: henrijl@evitech.fi

France
Barclay
16 Rue des Fossés
St.-Jacques
75005 Paris
+33.1.44.41.9595
E-mail: soph@imaginet.fr

Digital Mud Area
2 Sente des Badoises
95780 Haute Isle
33.1.34.79.7045
E-mail: fry-guy@francenet.fr

Grolier Interactive Europe
131 Avenue Charles de
Gaulle
92526 Nevilly
33.1.47.45.99.47
E-mail: depaleville@grolier.fr

Sabotage! Entertainment
6 Rue Damiens
92100 Boulogne-Billancourt
33.1.46.10.0909
E-mail:
sabotage@sabotage.fr

Germany
Goblin Design
Steigenhohlstrasse 48
76275 Ettlingen
49.7243.17253
E-mail:
silas@goblindesign.com

I-D Media GmbH
Dewanger Strasse 22
73457 Essingen-Forst
73403 Aalen
49.7365.96050
E-mail:
Bernd.Kolb@idgruppe.de

WYSIWYG Software Design
GmbH
Kasernenstrasse 24
D-40213 Düsseldorf
49.211.8670110
E-mail: dirx@wysiwyg.de

Hong Kong
That's Interactive Limited
7th Floor, 206 Prince
Edward Road West
Kowloon
852.2789.1339
E-mail: zeroex@hkstar.com

Indonesia
Adwork! Euro RSCG
Jl. Guntor 48
Jakarta 12980
62.21.830.9302
E-mail: adwork@rad.net.id

Israel
Netcreature, Ltd.
P.O. Box 06185
Jerusalem 91061
972.2.6797584
E-mail:
davidfx@netvision.net.il

Italy
rackEt MM
Via Isole del Capo Verde 15
00121 Rome
39.360.609717
E-mail: ulix@icom.icom.it

Japan
Express Co., Ltd.
Daiichi Shibuya Shimizu
Bldg.
1-11-8 Shibuya, Shibuya-ku
Tokyo
81.3.5485.1262
E-mail:
mkimura@express.co.jp

Kenji Saito
9-10-20-102 Konan-dai,
Konan-ku
Yokohama
81.45.831.4974
E-mail: psyche@yk.rim.or.jp

Korea
NeTalk, Inc.
4 Fl., Seokwoo Bldg. 650-18
Yeoksam-Dong Kangnam-
Gu 130-080
82.02.556.4687
E-mail:ensoph@netalk.co.kr

Young Hoon
4FL., Seokwoo Bldg.,
650-18
Yeoksam-Dong,
Kangnam-Gu,130-080
E-mail: sung@
younghoon-ps.seoul.kr

Malaysia
Beta Interactive Services
25 Jalan SS2/64
47300 Petaling Jaya
603.777.4508
E-mail: beta@po.jaring.my

Netherlands
Kristian Esser
Charlie Parkerstraat 13
1066 GV Amsterdam
31.20.4170040
E-mail: kristian@xs4all.nl

New Zealand
Ché Tamahori
P.O. Box 7127
Wanganui
64.21.650.190
E-mail:
ctamahor@wanganui.ac.nz

Norway
Mogul Media AS
OSLD Research Park
Gaustad Alleen 21,
PBoks 48, 0313
Oslo Norway
47.22.95.89.25
E-mail: jorgen@mogul.no

Singapore
Zouk Management Pte. Ltd.
17 Jiak Kim Street
Singapore 169420
65.738.2988
E-mail:
zoukclub@zoukclub.com.sg

South Africa
C3
9 Caroline Crescent
Cresta, Randburg
2194 Johannesburg
27.11.476.1078
E-mail: cococo@aztec.co.za

Electric Ocean
53 Wale Street
8001 Cape Town
27.21.246.299
E-mail:
hyperman@electric.co.za

Spain
Teknoland
Almirante, 16 - 1st Floor
28004 Madrid
341.532.01.07
E-mail: david@teknoland.es

Sweden
AdEra Digital Media AB
Östra Hamngatan 41-43
411-10 Göteborg
46.31.77.444.00
E-mail: gunilla.gudmunds@
hasselblad.se

Lekrummet Design
c/o Entertownment Network
P.O. Box 239
S-462 23 Vanersborg
46.521.193.65
E-mail:
jorgen_joralv@online.idg.se

Mats Renvall Produktion
Strindbergsgatan 44
S-115 31 Stockholm
46.8.664.20.54
E-mail: mats@renvall.se

Robot
Kungsgatan 66
S-1122 Stockholm
46.8.20.00.15
E-mail: loosme@robot.se

United Kingdom
The Hub
The Arts Council of England
14 Great Peter Sreet
London SW1P 3NQ
44.171.973.6581
E-mail:
rg@imagic.demo.co.uk

Interactive@Brann
Phoenix Way
Cirencester, Gloucestershire
GL7 1RY
44.1285.645340
E-mail:
Marketing@brann.co.uk

Ruairidh Lappin Associates
4 Squirrel Mews
Ealing, London W13 ORN
44.181.840.5823
E-mail: rla@dircon.co.uk

United States
Anderson Perrault Inc.
30 W. 72nd Street
New York, NY 10023
212.769.1716
E-mail: suza@interport.net

@tlas Web Design
2049 Ellis Street
San Francisco, CA 94115
415.440.4287
E-mail: olivier@sirius.com

Autodesk Inc.
111 McInnis Parkway
San Rafael, CA 94903
415.507.6794
E-mail:
webmaster@autodesk.com

Austin Knight, Inc.
100 Shoreline Hwy, B-100
Mill Valley, CA 94941
415.331.5600
E-mail: webmaster@ak.com

Avalanche
304 Hudson Street
New York, NY 10013
212.675.7577
E-mail: cherry@avsi.com

Boxtop Interactive
9014 Melrose Avenue
Los Angeles, CA 90069
310.246.0909
E-mail: info@boxtop.com

Brad Johnson Presents
937 Grayson Street
Berkeley, CA 94710
510.649.8444
E-mail: bradj@
bradjohnson.com

(C.A.P.)
Indulgent Arts
139 Richmond St.
El Segundo, CA 90248
310-322-5369
E-mail: craig@indulgent.com

Digital Planet
3555 Hayden Avenue
Culver City, CA 90232
310.287.3636
E-mail: theplanet@
digiplanet.com

Drawbridge Productions
2702 Ridgeview Lane
Walnut Creek, CA 94598
510.938.2186
E-mail:
zeno@Megan.netwizards.net

Gravica Design Group
215 Copley Rd.
Upper Darby, PA 19082
E-mail: graphics@
gravicadesign.com

Hal Riney &
Partners/Heartland, Inc.
224 S. Michigan Avenue
Chicago, IL 60604
312-697-5700
E-mail: rineyheart@mcs.com

Interverse
171 Pier Avenue, Suite 141
Santa Monica, CA 90405
310.581.8313
E-mail: vbennet@
interverse.com

IUMA
303 Potrero St., #7A
Santa Cruz, CA 95060
408.426.4862
E-mail: info@iuma.com

Luckman Interactive Inc.
1055 West 7th Street
Los Angeles, CA 90017
213.614.0966
E-mail: info@luckman.com

Modem Media
228 Saugatuck Avenue
Westport, CT 06880
203.341.5200
E-mail: lribolla@
modemmedia.com

NBC Multimedia Inc.
30 Rockefeller Plaza, Room
1637W
New York, NY 10112
212.664.2552

Oven Digital
611 Broadway, Suite 809
New York, NY 10012
212.253.1898
E-mail: info@oven.com

Organic Online
510 3rd Street, Suite 540
San Francisco, CA 94107
415-278-5500
E-mail:
cimeron@organic.com

Razorfish
580 Broadway
New York, NY 10012
212.966.5960
E-mail:
kanarick@razorfish.com

SocioX
Paper Multimedia Inc.
529 Broadway
New York, NY 10025
212.226.4405
E-mail: info@papermag.com

Syndetic Design
12108 Wycliff Lane
Austin, TX 78727
E-mail: dhopkins@
syndeticdesign.com

TWBA Chiat/Day
USA Networks
1230 Avenue of the
Americas
New York, NY 10020
212.408.3647

USA Networks / SciFi
Channel
1230 Avenue of the
Americas
New York, NY 10020
212-408-3647
E-Mail: sharleen@
usanetworks.com

COUNTRY CODES
http://burn.best.com/bob/
102195a.html
Listing for country codes in URLs.

DESIGN RESOURCE
http://www.lynda.com
Resource for Web design tips and techniques by leading Web book author Lynda Weinman.

DESIGN RESOURCE
http://www.spctrum.com/
cedge/resource.htm
Cutting-edge resources for Web designers.

DESIGN RESOURCE
http://www.photodisc.com
More than 32,000 royalty-free stock photos available from PhotoDisc. The site also features an easy-to-use search engine.

DESIGN SCHOOLS – US
http://www.arts.ufl.edu/
graphic_design/designschools.html
Schools in the United States with graphic design programs.

DESIGN SCHOOLS – WORLD
http://www.arts.ufl.edu/
graphic_design/worldschools.html
Schools from around the world with graphic design programs.

DOWNLOAD – ANIMATED GIFS
http://www.animagifs.com
Animated GIF89a graphics available for use on non-commercial Websites.

DOWNLOAD – BACKGROUND GIFS
http://eric.tcs.tulane.edu/images/
backgrounds/index3.html
Excellent site containing hundreds of GIFS to use as Website backgrounds.

DOWNLOAD – DESIGN TOOLS
http://ccn.cs.dal.ca/~aa731/
feathergif.html
Downloadable Macintosh Photoshop plug-in filter to create GIF images with blurry, transparent edges.

DOWNLOAD – DESIGN TOOLS
http://www.cooltool.com/
maxanimation.html
Cool tools for creating Web pages and graphics.

DOWNLOAD – DESIGN TOOLS
http://www.aris.com/boxtop/plugpage
Download PhotoGIF 2.0, a Photoshop plug-in for optimizing GIFs.

DOWNLOAD – DESIGN TOOLS
http://www.mindworkshop.com/
alchemy/gifcon.html
Downloadable Windows tools for creating GIFs or animated GIFs.

DOWNLOAD – DESIGN TOOLS
http://www.mit.edu:8001/tweb/
map.html
Online graphic tool to make transparent GIFs.

DOWNLOAD – DESIGN TOOLS
http://www.ohiocars.com/urlcheck/
resources.html
Web design tools and HTML editors, as well as links to other design resources.

DOWNLOAD – GIF ALPHABETS
http://www.dineros.se
Swedish font foundry featuring many unique GIF alphabets.

DOWNLOAD – JAVA SCRIPT
http://www.essex1.com/people/
timothy/js-index.htm
Archive of java script examples.

DOWNLOAD – PLUG-INS
http://browserwatch.iworld.com/
plug-in.html
One-stop shop for all the plug-ins on the net for Macintosh, UNIX, or Windows platforms.

DOWNLOAD – PLUG-INS
http://home.netscape.com/comprod/
products/navigator/version_2.0/
plugins
Netscape site for plug-ins.

DOWNLOAD – SHAREWARE
http://www.shareware.com
Large site featuring Mac or PC shareware and freeware.

DOWNLOAD – SOUNDS & MUSIC
http://www.geek-girl.com/
audioclips.html
Downloadable sounds, music, and voices.

EUROPE WEB DIRECTORY
http://www.yweb.com
European Web listings directory.

HTML WRITERS GUILD
http://www.hwg.org/
Organization for HTML programmers and designers.

LINKS – ICONS, BUTTONS, ETC.
http://eglobe.com/~melissa/links.html
Links to sites with good downloadable icons, buttons, and textures.

WEBTV
http://www.webtv.net/html/
home.about.html
Information about WebTV, a service that provides access to the Web through television.

WORLD WIDE WEB, COMPUTER MAGAZINES
For full listing see CD-ROM index.

Australia
Internet Australasia
http://www.interaus.net
Internet.au
http://www.i-net.com.au

Online World
http://idg.com.au/online.world

WebMaster
http://idg.com.au/webmaster

Hong Kong
Dataphile
http://www.dataphile.com.hk

PCWorld Hong Kong
http://www.pcworld.com.hk

Japan
Computing Japan
http://www.cjmag.co.jp

Malaysia
PCWorld Malaysia
http://www.jaring.my/pcworld

New Zealand
InfoTech Home
http://www.infotech.co.nz/hcurrent

InfoTech Weekly
http://www.infotech.co.nz

Russia
Computer Business Russia
http://koi.www.online.ru/emain/
ecomp/cbr

Singapore
Computer Times
http://www.asia1.com.sg/
computertimes

South Africa
MacTalk
http://www.advertising.co.za

Computer Buyer
http://www.gem.co.za/sacb/

PCWorld East Africa
http://www.africaonline.co.ke/
AfricaOnline/pcworld.html

United Arab Emirates
Computer News Middle East
http://gpg.com/cnme

PC Magazine Middle & Near East
http://www.pcmag-mideast.com

United Kingdom
Guardian OnLine
http://go2.guardian.co.uk

Internet
http://www.emap.com/internet

Internet Advisor
http://www.vnu.co.uk/advisor

Internet Today
http://www.paragon.co.uk/it

.net
http://www.futurenet.co.uk

United States
clnet online
http://www.cnet.com/contents.html

The Net
http://www.thenet.net.com

MMWIRE Web
http://www.mmwire.com

Web Review
http://www.webreview.com

Web Techniques.com
http://www.webtechniques.com

WEB COUNTRY CODES
For full listing see CD-ROM index.

ae	United Arab Emirates
an	Netherlands Antilles
at	Austria
au	Australia
ba	Bosnia and Herzegovina
be	Belgium
bg	Bulgaria
bo	Bolivia
br	Brazil
bw	Botswana
by	Belarus
ca	Canada
ch	Switzerland
cl	Chile
cn	China
co	Colombia
cu	Cuba
cz	Czech Republic
de	Germany
dk	Denmark
eg	Egypt
es	Spain
et	Ethiopia
fi	Finland
fr	France
gb	United Kingdom
hk	Hong Kong
id	Indonesia
ie	Ireland
il	Israel
in	India
it	Italy
jp	Japan
kr	Republic of Korea
kw	Kuwait
mx	Mexico
my	Malaysia
nl	Netherlands
no	Norway
nz	New Zealand
ru	Russian Federation
sa	Saudi Arabia
se	Sweden
sg	Singapore
uk	United Kingdom
za	South Africa
zr	Zaire

ABOUT THE WWW CD-ROM

The *WWW* CD-ROM is an interactive resource show-casing the Website projects presented in the *WWW* book.

Check out the "How To" section describing various Web design applications, with tutorials on basic Web design processes.

Check out the "Software" section to download Web design software.

BEFORE OPENING THE WWW CD-ROM

1. Be sure to turn off virtual memory in your control panel's "memory." When you do this you will need to restart your machine. This CD-ROM is compatible with RAM Doubler.

2. Set your monitor's color depth to 8-bit (256 colors). The *WWW* CD-ROM will not run properly otherwise.

WWW runs exclusively from the CD-ROM and does not install to your hard drive.

The *WWW* CD-ROM features links to each of the Website URLs featured in the *WWW* book. For optimal performance when linking to each country's Websites

we have included a self-contained *WWW* home page that can be accessed by your browser. This page will link you to the country's URLs.

To connect directly from the *WWW* CD-ROM follow the "Linking to the Web" instructions below.

TO PLAY THE WWW CD-ROM:

Macintosh:

1. Open the WWW folder on the CD-ROM.

2. Choose the "MacWWW PlayMe" or "PPCWWW PlayMe" file, whichever is appropriate for your system. The WWW CD-ROM runs best with at least 12MB of RAM. Choose the "WWW PlayMe" file that works best with your current available RAM.

3. Double-click the "World" icon and have fun. To bypass the opening, click the mouse button.

The "Help" button located on each screen will show you how to navigate the interface.

4. To download software to your drive click the appropriate "Mac" button on the "Software" screen. You can also go directly to the "softf" folder on the CD-ROM to reach all of the software files.

5. For more Web design software links, check out the "Resources" section on page 158 or go to the IYF area located in the contents section and check out the "Updated Resources" area on "inyourface.com."

Windows PC:

1. Choose "RUN" from the File menu. Type: (the letter of your CD drive) i.e. D:\WWW.EXE and then click "OK."

2. After the *WWW* CD-ROM starts you can bypass the opening by clicking the mouse button.

3. The "Help" button located on each screen will show you how to navigate the interface.

4. To download software to your drive click the appropriate Windows PC button on the "Software" screen. You can also go directly to the "softf" folder on the CD-ROM to reach all of the software files.

5. For more Web design software links, check out the "Resources" section on page 158 or go to the IYF area located in the contents section and check out the "Updated Resources" area on "inyourface.com."

LINKING TO THE WEB:

1. To connect to the WWW CD-ROM you need an internet connection through an Internet Service Provider. To connect to the Web from the CD-ROM open your internet connection the same as if you were going on the Web. Do not open your browser. If your browser is configured to start up your internet connection you may start at step 2,

2. Once you are connected to your provider, open the WWW CD-ROM and choose the Web project you would like to enter.

3. Roll over the "red sphere" in the top area of the "Web" screen. From this area you can link directly to the project's Website. Clicking on a project Web link will pop up a dialog box asking you to locate your browser. Once you find your browser, click OK. This sets the preference or INI file for future viewing of the CD-ROM.

Disclaimer

By opening the CD-ROM package, you accept the following: In no event will Rockport or its licensees, or Interactivist Designs be liable to you for any consequential, incidental, or special damages, or for any claim by any third party.